SECRET GUERNSEY

Amanda Bennett

AMBERLEY

To my parents, for their help, support and cups of tea.

First published 2015

Amberley Publishing
The Hill, Stroud, Gloucestershire, GL5 4EP
www.amberley-books.com

Copyright © Amanda Bennett, 2015

The right of Amanda Bennett to be identified as the
Authors of this work has been asserted in accordance
with the Copyrights, Designs and Patents Act 1988.

ISBN 978 1 4456 4319 9 (print)
ISBN 978 1 4456 4335 9 (ebook)

British Library Cataloguing in Publication Data.
A catalogue record for this book is available from the
British Library.

Typesetting by Amberley Publishing.
Printed in Great Britain.

CONTENTS

INTRODUCTION

Guernsey, the second largest of the British Channel Islands, is 40 miles of coastline and 25 square miles of countryside, farmland, roads and houses. With a population of around 63,000, there is a lot going on in a very small space, and the island's cultural heritage is just as densely packed and tangled. With deep roots in France – part of the trading routes for the Armorican Peninsular, and at various points in history, administratively part of the Duchies of Brittany and Normandy – the language, law and culture of the islands owes much to these early influences. Yet, for more than 1,000 years, the Channel Islands have been possessions of the English crown (with a few, brief periods of occupation by foreign forces) and, when these more familiar influences are added to the cultural mix, a rich and unique brew is created.

The Guernsey people are also shaped by their environment – island habitats are unsurprisingly dominated by their cultural, physical and economic links to the sea. Strategically, Guernsey also developed trade links at a very early point in its history, adding a surprisingly cosmopolitan flavour to the traditions and history of the capital St Peter Port, while simultaneously maintaining a more traditional fishing/farming lifestyle in the more remote parishes. The island has some of the oldest man-made structures in Europe (at Les Fouillages, L'Ancresse). The people display a sometimes stubborn adherence to traditional values, yet at the same time the island manages to participate fully in twenty-first-century life, with its dynamic and varied approach to enterprise and its successful international finance industry.

The complex and often contradictory history of the island has been well and thoroughly told in some of the books featured in the bibliography. The aim of *Secret Guernsey* is not to duplicate this work, but to illuminate just a small selection of the events, personalities, traditions and peculiarities that serve to enrich the island brew.

Some of the stories told here may be familiar, and some, it is hoped, will be completely new. The intention is to entertain and inform the local and visitor alike, with the hope that you might be drawn to exploring this fascinating island further. The character of the people is explored, including their entrepreneurial spirit and their secret vein of superstition. Some choice aspects of social history are highlighted – from burning witches, to duelling, to Vaudeville. There are stories of mapmaking, royal visits, restored gardens, oddly named streets and marmalade.

Above all, there are photographs to illustrate and intrigue. History does not occur in a vacuum and the subjects have been deliberately chosen because evidence of events can still be found on the island today. The photographs are by no means exhaustive and there may be more yet to see; a map will help you to find some of the sites mentioned so that you can explore the stories for yourself.

Most of the archive photographs and documents featured in this book come from the collections of the Priaulx Library – Guernsey's first free public library, which now specialises in local studies. With varied and unique collections, the Priaulx Library is a perfect place to explore the island further and it can also be discovered online at www.priaulxlibrary.co.uk. Funds from the sale of this book will help the library to continue to grow and develop as Guernsey continues to flourish in the twenty-first century.

<div align="right">
Amanda Bennett
Chief Librarian
January 2015
</div>

MAP OF GUERNSEY

Guernsey is divided into ten parishes, all of which feature in the book. However, due to space considerations, not all of the many objects, buildings or places mentioned in the book can be found on the map. More information about any of the topics can be found at the Priaulx Library.

 The following features can be found at Candie Gardens: Priaulx Library, Guernsey Museum, Queen Victoria Statue, Victor Hugo Statue and Victorian Bandstand. The following can be found at L'Hyvreuse: Prince Albert memorial tree and plaque, memorial duelling stone and Cambridge Park. (Map design by Tammy Sneddon).

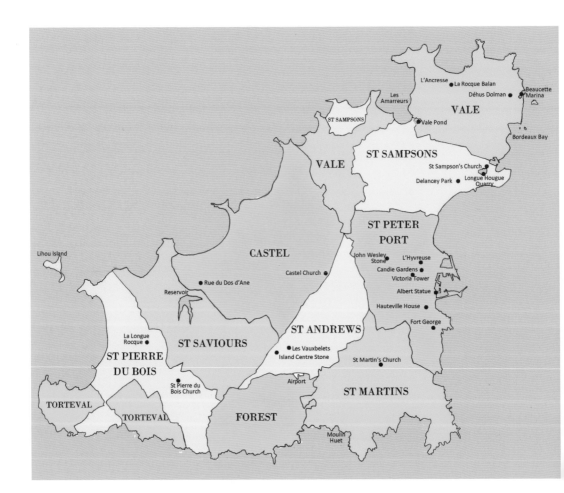

1
MAPS AND MILITARY ROADS

During the American War of Independence in 1776–82, it became increasingly clear to the British military that the Channel Islands were of strategic importance – France had allied herself with the United States and the islands were vulnerable to French attack. Before the beginning of the eighteenth century, the Channel Islands had officially been neutral in British Wars, but the islanders' increasing prowess in privateering activities was too profitable and successful to pass up, and they had laid aside their neutrality during the Seven Years' War. However, involvement in European wars came at a cost. Although coastal fortifications were built and reinforced, the Battle of Jersey in 1781, in which the island was invaded by a French expeditionary force commanded by Baron Philippe de Rullecourt, brought to vivid life the fears of the British. The later years of the eighteenth century saw the French Revolution followed by the Napoleonic Wars, during which the threat of French invasion was again high. Military intervention and invention was required to keep the islands safely in British hands.

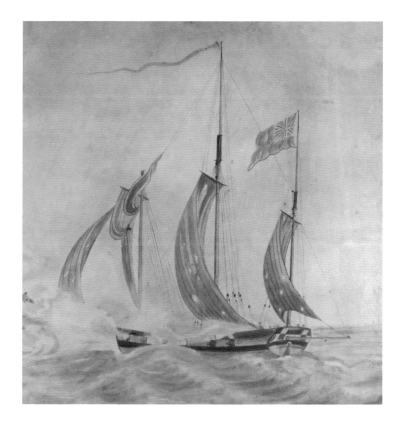

The Guernsey Privateer vessel the *Greyhound*, active during the Napoleonic Wars.

The Map

Arising out of this military need came a major, detailed survey of Guernsey undertaken by the Ordnance Office in 1787. Its survey was taken as a strategic exercise to ensure that roads, buildings and fortifications were properly described. However, it was also a significant survey in the history of the Ordnance. Charles Lennox, third Duke of Richmond, was appointed master general of the Ordnance in March 1782 and, as an army general himself, recognised the military potential of a detailed land survey. The use of the Corps of Engineers to undertake surveys for the Ordnance was well established, but the Duke also appointed the first professional, 'salaried' surveyors to undertake a great project to survey the whole of Britain. The surveyor in charge was William Gardner, a draughtsman who was appointed chief surveyor of the Ordnance in 1783. He and his partner, Thomas Yeakell, had originally been employed by the Duke of Richmond to undertake surveys of his estate at Goodwood in West Sussex, and the results were so impressive that the techniques they employed were extended to a national scale.

The first areas surveyed were of special strategic importance, including a map of Plymouth in 1784. This survey was significant because it used a scale of 6 inches to the mile – the first time that such a large scale had been used – and the importance of this map cannot be underestimated. Gardner then moved on to a survey of Guernsey and Jersey. The exact dates that he visited Guernsey are not known as the relevant records held at the Ordnance head office in Southampton were destroyed in the Second World War. However, the survey of Guernsey certainly took place no later than 1787 (which was the date inscribed upon the copper printing plates) and more likely between 1784 and 1786. Gardner probably employed a triangulation method – establishing a trigonometrical framework through a series of control points on a pattern to suit the scale of the finished map. It was painstakingly detailed work and it is not known how long Gardner took to finish the survey.

The William Gardner survey of Guernsey, affectionately known as the 'Duke of Richmond map', remained the only officially produced map of the island for more than 100 years. It is just as well that it was as accurate as it was. Nearly every gentleman's residence is marked, as well as a vast number of orchards and other plantations. Gardner's use of symbols was sometimes rather vague, and his place names almost non-existent, but the map is accurate enough to survive being overlaid on a modern digital map with only a little manipulation.

DID YOU KNOW THAT...?

William Gardner was one of the first surveyors to receive a salary. According to records preserved in the Ordnance Office, he was paid 2*d* an acre to survey the Channel Islands. A quick estimate of area reveals that Guernsey, at 24.5 square miles, contains around 15,680 English acres. Gardner therefore received 31,360*d* – or just over £130. It is not easy to calculate how much this would be worth today, but is probably a minimum of £20,000 and likely considerably higher.

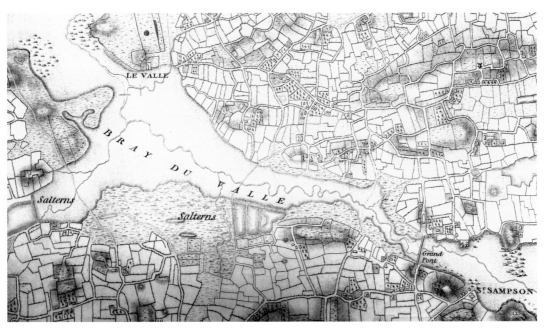

A detail of the Gardner map showing the Braye du Valle.

The Centre Stone

Because so little is known of the history of the William Gardner map, a number of intriguing puzzles remain unanswered. Chief among them is a stone that has been inlaid in the surface of Bouillon Road in St Andrew's, which is said to denote the geographical centre of the island. It is small and of plain stone, surrounded by granite setts, which has been in place since the late eighteenth century. It was briefly covered by tarmac in the late twentieth century, then re-found and restored in 2002 by the Public Thoroughfares Committee. This committee believed that the stone had been laid by a corps of Engineers stationed at Fort George, who were aiding Gardner in his survey of Guernsey in the mid-1780s. Could the stone have been one of his triangulation control points? Perhaps it had a military as well as a cartographical function? It is certain that calculating the geographical centre must have been a feat of engineering in itself, particularly if one considers that Guernsey has one of the largest tidal ranges in the world, and the area of land changes dramatically between high and low tide.

The Reclamation

The final thread of this story comes in the unlikely form of a land-reclamation project of 1806–08. One of the most startling and significant aspects of the Duke of Richmond map of 1787 is that it clearly shows Guernsey as two separate islands. The north of the island (Clos du Valle) was separated off from rest of Guernsey by a channel of water (Braye du Valle). Some of the Braye would have been fordable at low tide, but mostly crossings were made by boat, or at a number of narrow spots where land bridges had been built – most notably Le Grand Pont at St Sampson's (still known today as 'the

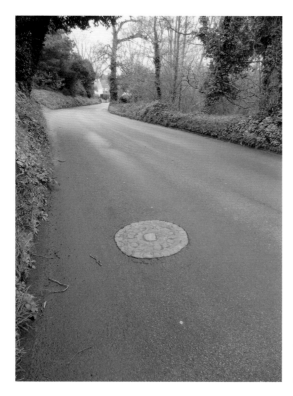

The island Centre Stone, placed in Le Bouillon Road, St Andrew's, in the eighteenth century and recently restored.

Bridge'), Le Pont Allaire at the Vale church and Le Pont Colliche at the Saltpans. It was the Duke of Richmond map that graphically revealed how very vulnerable the low-lying north of the island was to attack.

In 1803, Maj.-Gen. John Doyle was appointed lieutenant-governor of Guernsey. Dublin-born, a fine soldier and veteran of the wars against France and the United States, he was appointed precisely because of his military expertise at a time when the Napoleonic Wars (the short-lived peace of Amiens notwithstanding) were again threatening Guernsey's shores. One of his first acts was to petition the island to improve the roads for defensive purposes. Despite initial opposition to his ideas, he gave a stirring speech in which he defended the need and the cost of such an enterprise,

> ... let me now take you to England ... what is their policy? Are they narrowing the shores? – no such thing; they are doing the very opposite – they are putting them in the best possible state, to permit their brave and ardent defenders to move with the greater celerity to defend their shores and make the insolent foe repent of his temerity. I feel equal confidence in the gallantry of our loyal people...

He succeeded in winning over the States of Guernsey, and an ambitious transformation of roads and landscape began in the north of the island. Doyle's intention was to block each end of the Braye and drain the channel, thus reclaiming the land so that proper roads and defences could be built. The work was relatively straightforward; at the eastern end, the land

Braye Road, which runs through the centre of what was once the Braye du Valle.

bridge at St Sampson's (Le Grand Pont) was made watertight, and at the western, a breakwater was constructed of brick and rubble, to which was later added ballast from the quarry ships that passed through Grand Havre bay, thus reinforcing the wall. Sluice gates were later added at each end so that tidal inundations and flooding could be drained. By 1808, the land had drained sufficiently, and around 300 acres were freed for use. The only part left not drained was a small area near the Vale church, now known as the Vale pond. In the nineteenth century, it was well stocked with fish and was used for that purpose, but it is now owned by La Société Guernesiaise and, with an adjacent meadow, is kept as a nature reserve.

DID YOU KNOW THAT...?

Sir John Doyle was one of Guernsey's most popular and energetic lieutenant-governors and is commemorated in a number of ways around the island. A veteran of French and American wars, he was respected as a soldier as well as an administrator. As well as building roads, he founded a masonic lodge in the island – 'Doyle's Lodge of Friendship' – which still exists today. While lieutenant-governor, he also served as MP for the Isle of Wight and ended his career as private secretary to the Prince Regent – later George IV.

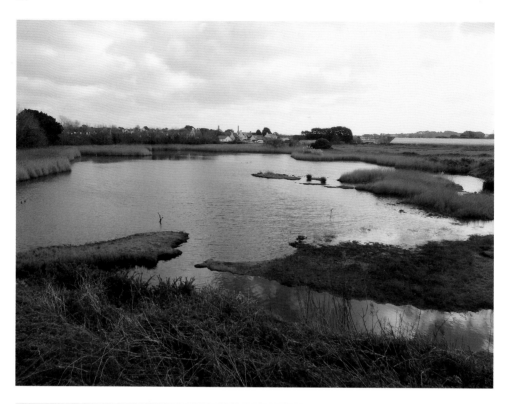

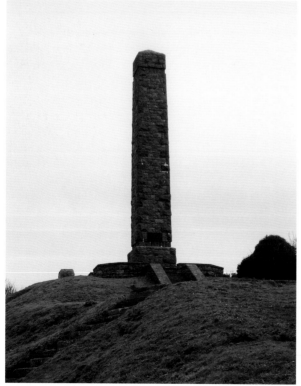

Above: The Vale pond – the last remnants of the channel that once divided Guernsey.

Left: Doyle Column. Erected in 1954, it is the third column on this site built to commemorate Sir John Doyle.

Doyle's cleverness extended to the funding of the reclamation project, which had been one of the island's initial misgivings. The inundated land of the Braye was actually owned by a consortium made up of the heirs of the first owner Henry de Vic, who received money from the Crown for every acre of land that was reclaimed. By 1805, very little of the land had actually been reclaimed, and Doyle persuaded the British Government to buy the land from the consortium for a price of £1,500 (around 1.5 million pounds today). In addition, the owners of the salt pans that were found on the foreshores of the Braye were compensated £1,750 (1.9 million). On the completion of the project in 1808, the 300 reclaimed acres were sold to six different individuals for a total of £5,000 (5.4 million pounds). Doyle then handed this money to the states as a gift to be used for the building of the new military roads. Thus, not only was valuable land gained for the island, the States of Guernsey were able to achieve significantly better roads and fortifications with a significantly reduced financial outlay.

Where does this leave the centre stone in the parish of St Andrew's? If it was indeed placed there in around 1784 as believed, then the calculation to find the geographic centre of the island would have been done using the southern shore of the Braye du Valle as the northernmost point. After the reclamation in 1808, Guernsey immediately became significantly larger and the centre point moved. Where should it now be? If the centre point has been calculated, nobody has yet bothered to mark it, so perhaps that is a project for the future. In the meantime, the centre stone in Rue Bouillon remains entirely redundant, yet at the same time serving as a reminder of the fascinating history of maps and military roads.

DID YOU KNOW THAT...?

Many of the road and house names around the Braye du Valle recall the time when it was a channel of water – The Bridge, Pont Allaire, Sandy Hook, Lowlands Road, and, of course, Saltpans Road. In 1806, Daniel Hardy owned and worked the largest salt pan in the Braye, at 23 acres. His salt was taken by boat to his store at St Sampson's harbour.

Left: Military Road, constructed by Sir John Doyle, which runs in a straight line for about a mile.

Below: Saltpans Road, St Sampson's.

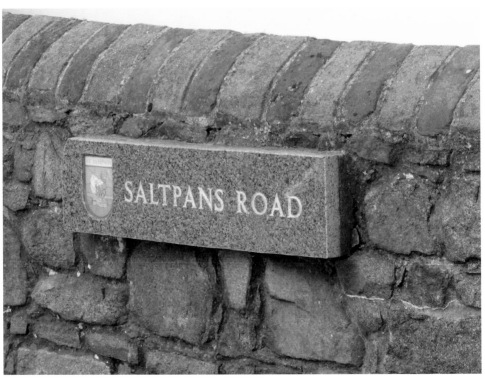

2
LITERARY LANDSCAPES

A surprising number of writers and poets have had associations with Guernsey. Some writers had slight connections, others lived in the Bailiwick for many years, or used the unique landscape as literary inspiration. For example, Jules Verne is known to have visited on his yacht, the great French writer François-René de Chateaubriand was shipwrecked on the north coast, P. G. Wodehouse went to school in Guernsey when he was a young teenager, Jack Higgins and Desmond Bagley made it their home, C. Northcote Parkinson became a Feudal Seigneur and Compton Mackenzie became the tenant of the islands of Herm and Jethou. The list is longer still, but there is no room to enumerate all the literary faces.

This chapter is rather about three writers who span the nineteenth century and provide a startling contrast in their styles and reputations. The first of these is an unlikely place to begin – James Fenimore Cooper (1789–1851). Author of many adventure novels, best known for his *Leatherstocking Tales* set in eighteenth-century colonial America and resident of Cooperstown in New York State, Cooper is an improbably candidate for Guernsey connections, and his connections are indeed slight, but there are enough to add a 'flavour' to his work. Certainly Cooper was better travelled than many of his

Jethou – the tiny island, home for many years to Compton Mackenzie.

contemporaries, for as a young man he had joined the Navy and is known to have visited ports along the Dover Straits, English Channel and the Mediterranean. Given the importance of Guernsey as an international entrepot at this time, it is not outside the bounds of possibility that Cooper laid anchor in St Peter Port one or more times. Guernsey features slightly in some of his nautical novels, including *Wing-and-Wing, The Pioneers, The Privateer* and *The Two Admirals.*

In 1811, Cooper married Susan Augusta Delancey, the daughter of a New York farmer. The Delancey family were aristocratic French Protestants who had emigrated to New York in the later years of the seventeenth century and were Loyalist during the American War of Independence. Possibly because of this professed loyalty, Susan Delancey's great uncle, Gen. Oliver Delancey, had joined the British Army and spent much of his life in Europe. His son, also Oliver, was barrack master in Guernsey from 1794 to 1804, and from him came the branch of Guernsey Delanceys who intermarried with prominent Guernsey families. Susan therefore had many Guernsey cousins.

James Fenimore Cooper was a greatly admired writer, not just in America but in Europe too. He was part of a tradition of writers in the mould of Sir Walter Scott, combining intelligent literary adventures with romantic, heroic characters in a vernacular landscape. Cooper was admired as much by the intelligentsia as the popular reader. One such admirer was the great French poet and author, Victor Hugo. Hugo said of him that, excepting (naturally) the writers of France, Fenimore Cooper was 'The greatest writer of the century'.

Hugo himself was often described this way by his contemporaries, and his reputation, already high when he left France to live in exile in the Channel Islands in the 1850s, reached new heights with his great novel, *Les Miserables*, published in 1862. He completed the final draft of the novel while living in Hauteville House in St Peter Port. He sat in a glass eyrie built on the top floor, high about the rooftops, with a magnificent view across the islands.

Hugo's time in Jersey (1854/55) and Guernsey (1855–70) as a political exile has been well documented, and the novel he set in Guernsey, *Les Travailleurs de la Mer* of 1866, is also well known. However, less known is his lovely little piece entitled *L'Archipel de la Manche*, which he wrote in 1866 and intended it to be a preface to *Les Travilleurs de la Mer*. For whatever reason it was not used for this purpose and was not published until

DID YOU KNOW THAT...?

The book for which James Fenimore Cooper is best known is probably *The Last of Mohicans*. In the novel, Cooper's hero, Hawkeye, attempts to rescue half-sisters Cora and Alice Munro en route to Fort Edward during the Seven Years' War. Cora is killed during a battle with rebel Huron Chief Magua. The death of Cora was said to be inspired by the infamous death of Jane McCrea at the hands of Native Americans near Fort Edward in 1777. Jane McCrea was the sister of Guernsey resident Col Robert McCrea, who was known by and distantly related to Susan Delancey's own Guernsey cousins. The story of Jane McCrea would have been well known in the Cooper household.

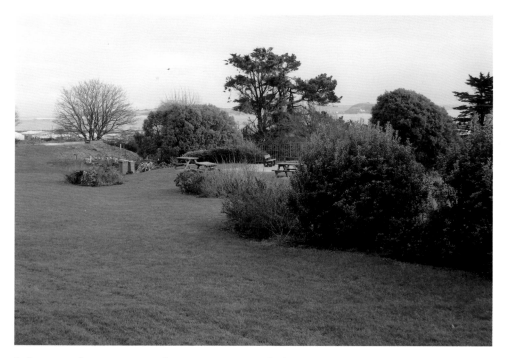

Delancey Park in St Sampson's, Guernsey – named after Susan Delancey Cooper's cousin Gen. Oliver Delancey.

two years before his death in 1883. It is worth reading for many reasons, not least for his vivid and affectionate descriptions of local scenes and scenery.

L'Archipel de la Manche is almost a stream of consciousness, alternating historical facts with myths and sense impressions of the scenery around him. Hugo brings Guernsey to life in an unusual and memorable way that still resonates today.

On the rocky coast he writes,

This is what the deformed coastline looks life. Approach it. There is nothing there. The stone can vanish. Here is a castle, there a primitive temple, there a jumble of ruins and demolished walls, all the traces of a deserted town. But neither the town, the temple or the fortress exist – they are just cliffs. [Author's translation]

DID YOU KNOW THAT...?

The best known mounting block in Guernsey is outside the property of Mon Plaisir in St Jacques and is known as 'The John Wesley Stone'. The great Methodist minister Wesley stood on the stone to preach during his visit to the island in 1787, winning many Guernsey converts.

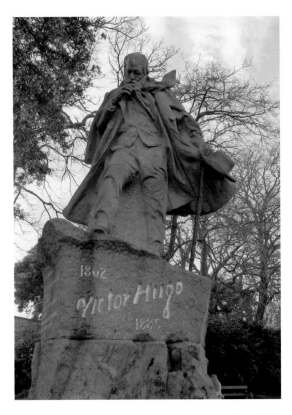

Statue of Hugo in Candie Gardens, unveiled in July 1914.

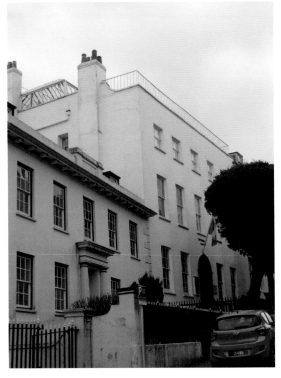

Hauteville House, No. 38 Hauteville, St Peter Port.

Guernsey cliffs – 'a jumble of ruins and demolished walls'.

Similarly jumbled, in Hugo's eyes, were the picturesque houses and cottages of the island interior. He writes of the 'monumental' farmhouses with their circling walls, arches and carriage gates, as well as the pretty but tumbledown cottages of the humbler folk – 'The hamlets under the trees are dilapidated and lively, the cottages are as ancient as cathedrals.'

Hugo also notices the everyday objects that many of us overlook: 'Every exterior door has a granite mounting-block'. Many of the ubiquitous mounting blocks that Hugo notices can still be found today. Their survival owes much to their construction from the heavy and durable Guernsey granite. However, a survey of mounting blocks has never been undertaken and there is no list of them; many surviving examples could potentially be lost as properties are developed.

Although Hugo writes about the fauna and abundant flora of the countryside and coast, he is also quick to pick out the human influences on the landscape: 'The livestock drink out of troughs that look like sarcophagi. A Celtic king might have decayed in this granite trough where a cow with eyes like Juno quenches its thirst.'

Like mounting blocks, these stone troughs can be found all over the island still – many on private land, but many also built by the parish for watering cattle and horses as they passed to and fro. These large watering places are known as *Abreuvoirs*.

Hugo also writes of St Peter Port and its people – such a contrast to the rural tranquillity of the countryside. His great novel, *Les Travailleurs de la Mer*, also contains many and detailed descriptions of St Peter Port, but in *L'Archipel de la Manche*, he was

A deserted cottage in St Andrew's – 'Dilapidated and lively'.

Carriage gates – known as the Ivy Gates in Rohais Road, St Peter Port.

A mounting block at the north gates of St Pierre du Bois church.

The John Wesley Stone in St Jacques, St Peter Port.

quick to find the essential charm of the town, which still appeals to visitors today: 'The Town is terraced on a delightful disorder of valleys and hills gathered around the Old Harbour just as if they had been squeezed in the fist of a giant. The ravines form the streets, the stairways make short cuts.' St Peter Port is a town of hills. It climbs up a cliff from the harbour, and is a place full of alleyways and rooftops – little changed in this respect since Hugo's time.

An admirer of Fenimore Cooper, Hugo was admired in his turn by many European writers – not least by the English poet Algernon Swinburne. Swinburne was a decadent, alcoholic aristocrat with many mental and physical frailties, but as a poet, his reputation has always been high, although he is not very fashionable today due to his somewhat florid style. Like his hero Hugo, Swinburne writes much of the natural world, but he treats it as a metaphor rather than a representation.

Swinburne's first encounter with Hugo was when he wrote a review of *Les Miserables* for *The Spectator* magazine in 1863. Although Swinburne's praise for the work was somewhat tempered, he nevertheless sent the review to Hugo in Guernsey – an action he later confessed to a friend had shocked even himself in its boldness. Hugo replied with great affability and praise, and Swinburne was his slave from that moment on, referring to Hugo in a letter as *'Le Maître qu'on a toujours vénéré'* ('The Master we have always revered'). Their correspondence was slight but filled with mutual congratulations on their completed works. In a letter to Swinburne written from Hauteville House in 1866, Hugo thanks the poet for dedicating his verse-drama *Chastelard* to him, writing, *'Votre oeuvre est au plus haut point émouvante et humaine'* ('Your work is to the highest degree moving and compassionate.')

Given all this, is it somewhat surprising that Swinburne didn't visit Guernsey until 1876 – several years after Hugo had given up permanent residence there. Nonetheless, Swinburne, staying at the Victoria Hotel in St Peter Port High Street (now Marks & Spencer), was obviously moved by tracing Hugo's own steps in his explorations of the Guernsey south coast cliffs (a favourite walk for Hugo) and in visiting the island of Sark, which reminded him of passages from Hugo's *Les Travailleurs de la Mer*. As a young poet, Swinburne had been much influence and inspired by seascapes, not surprising as he had grown up in the Isle of Wight. He saw similar landscapes in the Bailiwick of Guernsey, but wilder and stranger, and they inspired him to write several poems, which he published as part of his collections – *Songs of the Springtide* (1880) and *A Century of Roundels* (1883). In the latter collection, his poem 'In Guernsey' describes the south coast cliffs that he and Victor Hugo loved so well:

> The heavenly bay, ringed round with cliffs and moors
> Storm-stained ravines, and crags that lawns inlay,
> Soothes as with the love the rocks whose guard secures
> The heavenly bay

Hugo and Swinburne were not the first or the last writers to be inspired by Guernsey, but they are perhaps the best known. What of home-grown writers? Many writers, like Hugo, made their home on the island including Nicholas Monsarrat, author of *The Cruel Sea*, and Elizabeth Beresford, creator of the Wombles, who lived in Alderney for much of her life.

An abreuvoir at Sous l'Eglise, St Saviour's.

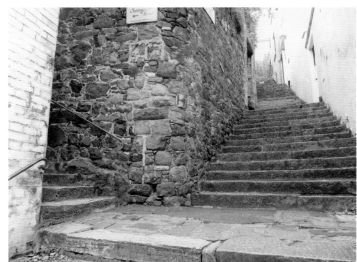

The steep streets and stairways of St Peter Port.

DID YOU KNOW THAT...?

One of the most loved novels about Guernsey was *The Book of Ebenezer Le Page* by Guernsey-born Gerald Basil Edwards (1899–1976). Published after his death in 1981, it was greeted with great critical acclaim and championed by Jonathan Fowles and William Golding amongst others. Professor Stephen Orgel of Stanford University called it 'one of the greatest novels of the Twentieth Century'. It is the fictional autobiography of irascible Ebenezer Le Page from his childhood to the end of his life, including the effects of the German occupation of 1940–45. It a must-read for anybody interested in Guernsey life and landscape.

n. Marguand ... que je mette à tion aux ... de madame Marguand

Victor Hugo

H. H. 8bre 1865

LES CHANSONS

DES RUES ET DES BOIS

Victor Hugo's signature (*Priaulx Library*).

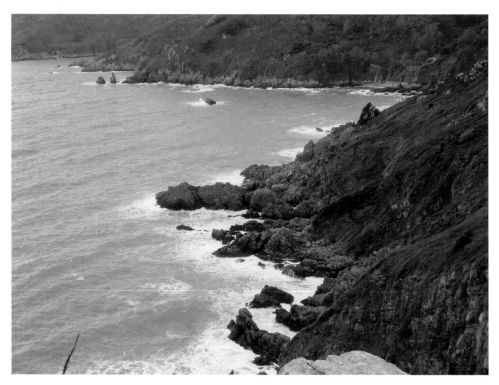

'The heavenly bay' – Moulin Huet on Guernsey's south coast.

3

THE SECOND LIFE OF GUERNSEY QUARRIES

Quarries are a comparatively recent addition the Guernsey landscape, but they are a significant one. Their life and importance to the Guernsey economy and infrastructure has lasted way beyond their initial function and will continue to do so for the foreseeable future. The history of quarrying in Guernsey is a long and fascinating one, but it is also interesting to consider the 'second life' of quarries and to wonder where Guernsey's waste and water strategy would be without them.

At the height of Guernsey's stone industry in the late nineteenth century, there were over 250 working quarries exporting vast quantities of mainly granite. In 1910, 458,000 tonnes were exported. The rapid growth in quarrying had a parallel effect of Guernsey society. A large number of skilled workers were required and they came, in the early days, as immigrants from Cornwall and Devon. At the end of the nineteenth century, a lot of the labour force was drawn from France – particularly to do the really tough physical tasks, such as stone-cracking. The harbour of St Sampson's also grew rapidly into a busy commercial port capable of handling large heavy cargos. In 1900, with over 1,000 people employed in the industry, it had become a tradition and a way of life, with different generations of the same families involved.

According to G. Greenwell who wrote an article for *The Quarry* magazine about Guernsey quarries in 1897, 'The island of Guernsey is one great mass of intrusive rock of varying character.' By and large, the intrusive rock, mainly Gneiss and Diorite of granite types, is strong, durable and ideal for building. In particular, the quartz-diorite intrusion to be found in the north-east of the island, which yields Guernsey's famous blue granite, is so durable it can withstand immense pressure (up to 950kgs per cm^2) and is used locally for sea defences, steps, walls and other fixtures intended to be at the mercy of the elements. A significant

DID YOU KNOW THAT...?

The stone industry had a massive impact on Guernsey's population in the nineteenth century. Between 1821 and 1911 the island population doubled. However, while the population of the main town of St Peter Port and that of the rural parishes grew modestly and steadily, in the parishes of the Vale and St Sampson's, where most of the quarrying was taking place, the population more than quadrupled during this time. Roads, houses, shops and churches (particularly Nonconformist chapels) all sprang up in the north of the island to service the growing population.

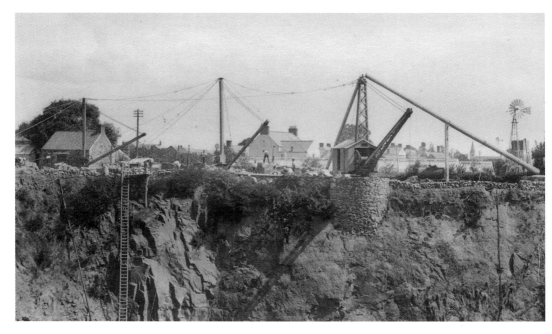

Les Romaines Quarry, St Sampson's, quarrying Bordeaux Diorite.

majority of the stone quarried in the late nineteenth and early twentieth centuries was crushed to be used as aggregate in tarmacadam road surfacing. The stone-breakers used to make the aggregate were massive and powerful – Mowlem & Co. at their quarry near the Vale Castle had two in 1897 that were each capable of breaking 300 tons of stone per day.

The stone industry started to decline throughout the 1920s and 1930s, partly due to the rising costs of export and also to the increasing use of asphalt for road surfacing. The German occupation of the Channel Islands also contributed to the decline; the German forces did open some of the quarries for their own use, notably Bordeaux and Hougue Noirmont, but they ran the machinery into the ground with no spares to be found in the wartime conditions. Other quarries were left to fill up with water and mud, and these were expensive and time-consuming to clear after the war. Only the firms of A. & J. H. Falla and Griffiths made the attempt. Exports were drying up, however, partly due to the relative cost of crushing and transporting. The former firm stopped exporting aggregate in 1959 and the latter in the 1960s. In 1961, the Jersey Cement & Granite Co. acquired the quarries of Mont Cuet, Bordeaux, and Les Vardes, and continued to operate. They still operate today under the name of Ronez and are owned by Aggregate Industries. Les Vardes is the only working quarry left in Guernsey mining granite for aggregate. The firm also produce asphalt and concrete products for the local building industry.

A Quarry Lifecycle – Bordeaux

The quarry near Bordeaux Harbour was sited just a few metres from the beach. During its working lifetime of over 100 years, it allegedly yielded 3.5 million tons of blue diorite. It was one of the quarries used by the German Occupying Forces in the Second World War, but they

The sea wall at La Lague Hervy, built with blue granite (quartz-diorite).

Ronez concrete works at Longue Hougue, St Sampson's.

left it in a poor condition and it inevitably flooded with water and silt. Griffiths, who restored the quarry to working use after the Second World War, spent almost a year pumping it out before any quarrying could begin. Griffiths used a ropeway system and a Blondin to move blocks of stone out of the quarry and onto a small railway. The unmanned track ran the short distance around Bordeaux Bay, gradually climbing and crossing a small steel bridge over Les Maresquets Lane until it reached the stone-breaking yard near to the Vale Castle.

The quarry was no longer worked after the mid-1960s, and was very quickly pressed into use as a landfill site. Rubbish disposal was starting to become a problem in Guernsey at this time and it was thought that disused quarries could be used as very handy rubbish receptacles. Unfortunately, Bordeaux quarry was filled in no time at all and rubbish continues to pose a problem to island authorities. There is now no hint of the quarry's sheer size and depth. Instead, there is a gentle green mound over the site of the landfill, which has now been designated the Bordeaux nature reserve. For a more tangible reminder of the quarry, in nearby Les Maresquets Lane, the steel rail bridge that once helped to transport stone to the stone-breaking yard can still be found – now picturesquely covered in ivy.

Water, Water, Everywhere – Quarries as Reservoirs

Anyone flying over the north of Guernsey cannot fail to be amazed at the sheer number and variety of water-filled quarries to be seen. Often hidden behind hedgerow, gardens and walls in the network of lanes of that part of the island, they cannot be readily viewed from the road and come as something of a surprise to the uninitiated. Using spent quarries as reservoirs is in many ways a natural extension of their life, and one which does not, initially, require a great deal of infrastructure. Streams can be diverted and nature and rainfall take their usual course to fill them.

Guernsey's water capacity is around 4,000 megalitres – or 400 million metres3. Around 1,000 megalitres of this is in the St Saviour's reservoir. The rest is stored mainly in disused quarries. Of these, Longue Hougue is the largest by a very long margin. It is 60 metres deep and holds 1,400 megalitres. It is a vital lynchpin in Guernsey's water network, containing enough water for around three months' supply. It would make a vital difference in the event of a drought. Other quarries include Juas, Grosse Hougue and Hougue Ricart.

A new state-of-the-art water treatment plant was built at Longue Hougue in 2009, which employs membrane technology – microfiltration that physically separates out particles in a very energy efficient way.

DID YOU KNOW THAT...?

Juas Quarry is probably the quarry with the oddest name. In fact, the word *Juas* does not exist in any language and owes its existence to a misspelling! The hill above was originally known as La Hougue Cas, after the Cas family. In some documents, Cas was spelled in the French manner as *Quas*, and at some point in the sixteenth century this was misread as 'Juas'.

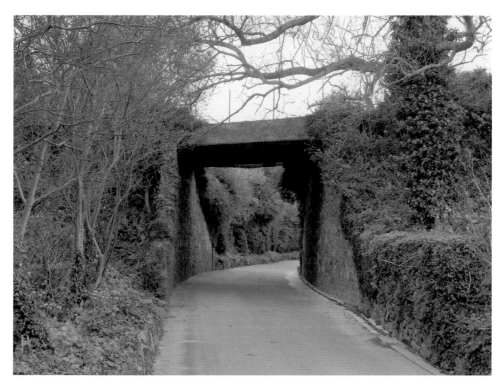

The steel rail bridge at Les Maresquets Lane, Bordeaux.

The concrete blocks that formed the base of the Blondin at Bordeaux Quarry.

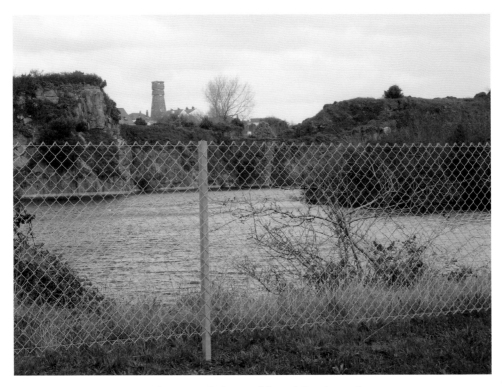

Juas Quarry – a pretty, tranquil place in the heart of the Vale's industrial area.

Longue Hougue is enormous, yet is right in the middle of one of the most industrial and densely populated areas of the island. During its life as a working quarry, its proximity to houses and the ancient parish church of St Sampson's was something of a concern. Erosion of the edge of the quarry, and the fact that the church is alarmingly close, had its inevitable conclusion in the summer of 1969 when a major landslip sent part of the church graveyard sliding into the quarry along with all the coffins and tombstones. The incident marked the end of Longue Hougue's life as a working quarry.

A Long Environmental Legacy – the Torrey Canyon Quarry

The Torrey Canyon disaster in 1967 was one of Britain's worst environmental disasters. The ship, which went down in high seas off the Scilly Isles, spilled around 120,000 gallons of crude oil, which devastated shorelines, beaches and wildlife. It was a particularly unlucky time for Guernsey as the state of the tides and winds brought the oil across the Channel and onto the north-western beaches of Guernsey. The detergents and other chemicals used in clean-up by the UK Government on the English Coast had not been entirely successful, and were themselves environmentally unfriendly and somewhat controversial. The Guernsey solution to the clean-up consisted of scooping up the oil from the beach and the sea and pumping it into a disused quarry on the Chouet headland.

The Torrey Canyon Quarry – as it immediately came to be known – was a fairly substantial size, yet it was reported that the oil layer after the clean-up was 10 metres

View of Longue Hougue Quarry from St Sampson's Churchyard.

deep. Sometime later, it was discovered that the oil was still somewhat usable in the right circumstances, and it was pumped out to fire the furnaces that kept the Guernsey Greenhouses warm. In the 1990s, some was even exported, and in 1996 alone almost 800 tons of oil were removed from the quarry for use elsewhere. This alone could not solve the problem, which was largely an environmental one. Not only was the quarry unsightly and odorous, but also dangerous to wildlife. Finally, in 2010, a solution was found in bioremediation – a technique of introducing naturally occurring organisms capable of breaking down the oil into non-toxic substances. It will not be long before the last of the Torrey Canyon oil finally disappears from Guernsey.

From Work to Recreation – the Beaucette Marina

Finally on the tour of quarries is the Beaucette quarry in the far north-eastern tip of Guernsey. Quarried for blue granite for many decades, it was a mere stone's throw from the open sea, and was one that was abandoned after the Second World War. In the 1960s, a consortium known as Vale Investments purchased the quarry with a view to opening it up to the sea, thus creating a safe haven and a marina for pleasure craft. Their clever, entrepreneurial and cost-saving scheme was to invite the Royal Engineers to blast out the rock on the seaward side of the quarry as a training exercise. The army accepted the offer for a budget of £725 and all seemed to be well. However, the Royal Engineers, who arrived in the island in July 1968 aboard the landing ship *Sir Percival*, had not reckoned on the sheer durability and

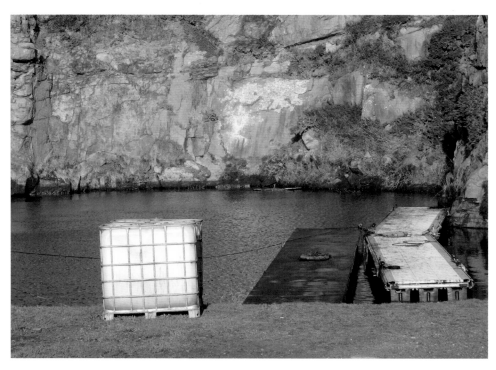

The Torrey Canyon Quarry. The quality of the water is improving due to bioremediation treatment.

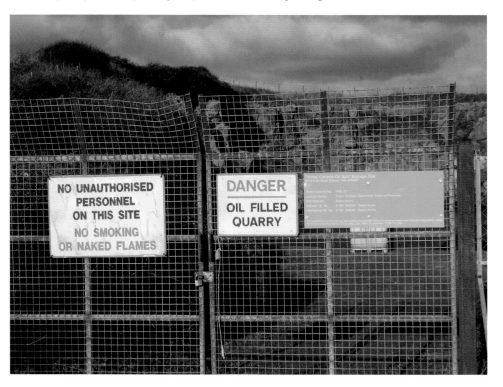

Warning signs at the Torrey Canyon Quarry.

strength of the local blue granite. The 6 metres or so of solid rock that needed to be removed to form the marina entrance proved resistant to traditional methods, such as boring and small-scale blasting. A job that was intended to be completed in weeks suddenly appeared a lot more complex, and the Sappers admitted defeat and left the island in October, their task incomplete. They returned the following year, and after six months of hard work (and the sea working against them), they succeeded in removing over 5,000 tons of granite. The quarry was finally opened to the sea. The £725 job eventually came to a cost of an astonishing £27,000, the bulk of which was paid by the British taxpayer.

The merits of this aside, there is no doubt that Guernsey benefitted enormously from the new marina. The marina was sold in 1995 for the princely sum of £1.75 million.

DID YOU KNOW THAT...?

The streets of London are paved in Guernsey granite. One of the largest quarry owners in Guernsey in the nineteenth century was John Mowlem, who won the contract to repave Blackfriars Bridge, the Strand and the Thames Embankment. It is also said that the stone used to build the steps to St Paul's Cathedral came from a small quarry on the tiny islet of Crevichon, off Guernsey's east coast.

The entrance to Beaucette Marina showing where the Royal Engineers had to blast through the granite.

4

A GENTLEMAN'S HONOUR

Guernsey possessed an English garrison from a very early date. It was stationed for many centuries at Castle Cornet, then from the late eighteenth century at the rambling citadel of Fort George. The various regiments brought life and colour to the island (along with the occasional mutiny), and many of the men and officers married into local families. Towards the end of the eighteenth century, the mixture of hot-headed military officers, Guernsey gentlemen and an age in which a man's honour was paramount, resulted in quite a number of duels being fought – some in which the combatants had a lucky escape, and others with fatal consequences.

The Lucky Escape

Mr Pierre Mourant of Candie House was dining with his friend, Mr Anthony Priaulx, at the officers' mess at Fort George. In the early years of the nineteenth century, Fort George was the primary English garrison – a large sprawling camp, rather than a traditional fort. According to the reminiscences of Mr F. C. Lukis, during the dinner an argument ensued between an ensign of the regiment and Mr Mourant, which ended in an exchange of cards and, inevitably, a date arranged for their 'meeting' by which term duels were euphemistically known. As with many 'affairs of honour', the exact subject of the argument has been lost to history, although it was agreed by the officers dining that day that the remarks made by both parties had indeed been insulting.

The duelling site was duly agreed and, early the next morning, the combatants met in the unromantic surroundings of a brickfield opposite the fort. Duelling was illegal and the rules of conduct of such affairs usually specified that the number of persons present should include the duellers, their seconds, an impartial observer and a doctor. However, on this fateful morning, on arriving at the brickfield, Mr Mourant and the unnamed ensign found not only all the officers who had been in the mess during the argument eagerly awaiting entertainment, but a large number of the soldiers of the rank and file assembled also. Alarmed and embarrassed, the two men made no attempt to speak or reconcile, and immediately took their positions, raised their pistols, and at the signal, fired.

Pierre Mourant jerked, staggered back a couple of steps and cried, 'I'm hit.' The doctor ran over, but, after a brief examination, found no blood, despite Mourant's insistence that he had felt the bullet. The affair might have ended there, but the watching soldiers were not satisfied by this tame end and demanded that the duel continue. The men fired again and both missed. Honour was apparently satisfied. Mr Mourant shook hands with the ensign and all parted friends.

On returning home, Pierre Mourant, in considerable pain, took off his shirt and found a large and unsightly bruise in the centre of his chest. Alarmed and puzzled, he informed Anthony Priaulx, who immediately returned to the brickfield to try and discover what

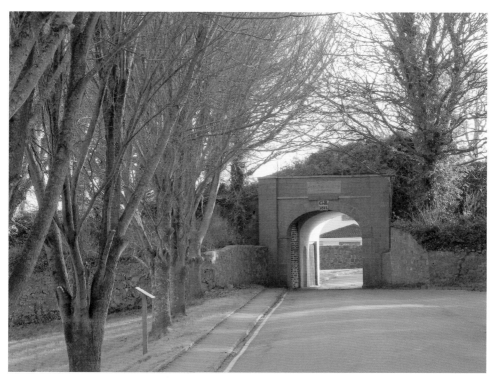

The George III entrance gate to Fort George. Very little else of the citadel survives.

The site of the old Brickfield where Pierre Mourant duelled an ensign of Fort George.

had happened. Standing in the exact spot his friend had stood that morning, he noticed a dented brass button lying on the ground. Had the ensign's bullet struck a button on Mourant's coat? If so, it certainly saved his life.

'Hats Off!'

William de Vic Tupper was an enthusiastic serial duellist who, until 1798, had lived a somewhat charmed life. The middle son of a wealthy and influential family, he was not obliged to work, and the only cloud that hung over him was his unfortunate tendency to be argumentative and hot-headed. According to his friend, the ubiquitous Anthony Priaulx, he had fought several duels as a young man, surviving each without a mark upon him. However, in 1798, when he was forty-one-years-old, he was to fight one last time.

Duels were often fought on the flimsiest of excuses or the most trivial of slights. Tupper's last fight was no exception. He was attending the theatre with friends when the national anthem was played before the start of the performance. The general cry of 'Hats Off!' was heard as the men stood to honour the king. Tupper, deep in conversation, failed to heed the cry and remained seated with his hat on his head. An officer of the regiment took affront and shouted, 'Take off that scoundrel's hat and throw him over!' Tupper took offence in his turn and a public argument and scuffle ensued in which cards were exchanged and satisfaction demanded.

Tupper refused to apologise, nor accept any apology, but perhaps he knew deep down that he was pushing his luck. In an odd little tale related by Anthony Priaulx to F. C. Lukis, it appears that Tupper approached the duel feeling that his good fortune had run out. He was walking in St Jacques where a stream ran down the middle of the road. Moving to cross the stream, a rat ran in front of him along the path he was about to take. Tupper was eating an orange at the time, so he took this out of his mouth and threw it at the rat. He missed and took this to be a bad omen saying, 'Priaulx, I'm hit this time.' His prediction was correct. The duellists met at L'Hyvreuse, each firing twice. The second bullet hit Tupper and he died almost instantly.

This tale, and several others, comes from the reminiscences of Frederick Corbin Lukis (1788–1871) found in a manuscript preserved at the Priaulx Library. Lukis was born in St Peter Port and is best known today as an antiquarian and archaeologist responsible for excavating Le Déhus dolmen and the passage grave at La Varde on L'Ancresse Common. He was a highly respected and important island figure. He also personally knew Anthony Priaulx and Pierre Mourant, so his tales have some authenticity.

DID YOU KNOW THAT...?

The theatre where Tupper was challenged to a duel was built by the great actor and theatre entrepreneur John Bernard in 1794. After Bernard persuaded his patron George, Prince of Wales, to lend his patronage to the theatre and to his 1795/96 season in Guernsey, the theatre became known as the Theatre Royal. It was near the magistrate courts – probably on the corner of Lefebvre Street and Court Row.

Tupper's stream at St Jacques, which now runs underground.

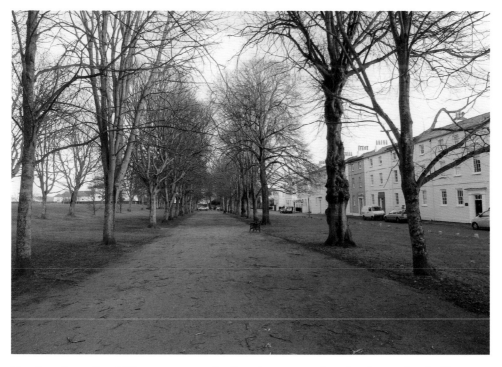

The charming walk at L'Hyvreuse – a popular Georgian promenade and early morning duelling spot.

A Melancholy Event

On 13 February 1795, the Governor of Guernsey, Maj.-Gen. Small, received the following communication:

> With heartfelt sorrow & deep regret, I have to report to you the unforeseen and melancholy event of the untimely death of Major Byng 92nd Regt. who fell in a duel this morning about an hour ago by Surgeon James Taylor of the said Regiment.

It was signed by Capt. William McCaskill, now temporarily in charge of the regiment due to the death of his commanding officer. Poor Capt. McCaskill was understandably upset because Byng and Taylor were known to be good friends. What had occurred to make the men take such a drastic step? Not only had the duel sprang out of the blue, but the two officers also went to the duelling spot at L'Hyvreuse unattended by seconds or doctors – highly irregular behaviour.

The exact cause of the duel remains tantalisingly vague. Later reports seemed to indicate that the bone of contention had yet again been the national anthem. One report has it that Dr Taylor was slow to rise on hearing it at mess, to which Byng took offence. Yet another report tells that Byng had failed to recognise the national anthem when it was played by the regimental band, which was taken as an offence by Dr Taylor. Neither story seems credible as the cause of a duel, but perhaps there was some other offence unknown to everyone but the duellists themselves?

Whatever the cause, the consequence was deeply felt – the regiment having lost a popular and respected officer. Byng was accorded a burial with full military honours and a stone was later erected to commemorate the event. The fashion for duelling died out in the early years of the nineteenth century. The stone was placed next to an elm tree upon which Byng and Taylor had carved their initials before the duel.

Anthony Priaulx – a Reformed Man

This tale of duelling features Mr Anthony Priaulx several times, acting as a witness or a second to the duels of others. It is no surprise, therefore, to discover that he was fond of duelling on his own account and one of his exploits has been passed down.

Priaulx, despite his liveliness and predilection for trouble, was nonetheless a kindly soul and fond of his friends and family. His brother John became enamoured of Miss Le Mesurier of Plaisance in St Pierre du Bois, but being shy, asked his friend John de

DID YOU KNOW THAT...?

The elm tree that Byng and Taylor carved their initials into was one of several that had been planted in March 1713, and was already eighty-two years old when the duel was fought. In 1965, the trees, now nearly 250 years old, were condemned. It is said that the 'B' of Byng's initials was still visible at this time. The inscribed tree survived on a little longer, but was eventually felled in March 1971 and cut up for firewood.

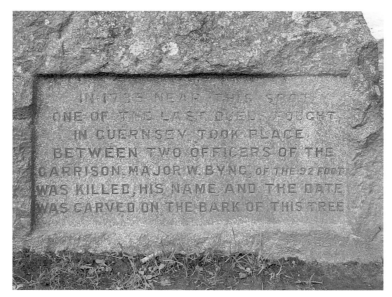

The stone commemorating the duel of Byng and Taylor at L'Hyvreuse in 1795.

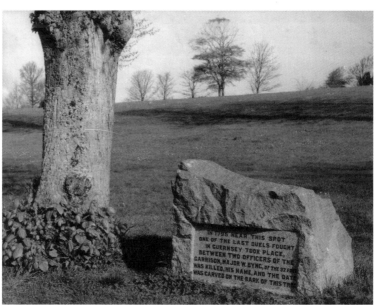

The tree and stone just prior to felling in 1971.

Lisle to talk to Miss Le Mesurier on his behalf and tell her of his regard. The inevitable followed: John de Lisle fell for Mary Le Mesurier on his own account and his esteem was apparently returned by the lady in question. Enraged by this, and despite being six years his brother's junior, Anthony immediately challenged John de Lisle to a duel. He proceeded to put a bullet in de Lisle's torso, which failed to kill him, but which ended up lodged close to his heart. De Lisle was to carry that bullet with him for the rest of his life, until he died in 1829 at the age of sixty. He did indeed marry Miss Le Mesurier and poor John Priaulx never married.

Evidently, Anthony Priaulx had a reputation as a serial duellist, as well as having a somewhat erratic and unsteady character. After his death in 1820, he was described by Thomas Brock as follows: 'He considered the disposition to fight so essential to the character of a gentleman, that the lesson he most frequently inculcated on his young sons, was, never to tolerate an injury, but to call out every man who should dare to insult them.' However, after a serious accident in 1810, he had a radical change of personality and became a reformed man, praying every day, visiting the poor and doing other good works. In the words of Brock, 'The Lion was changed into the Lamb.' Presumably, he never duelled again.

DID YOU KNOW THAT...?

Anthony Priaulx's youngest son was Osmond de Beauvoir Priaulx. After Anthony's 'conversion' in 1810, instead of telling his sons about the virtue of fighting duels, he changed to lecturing them on the benefits of humbleness and charity. His words must have had some effect because, in 1869, Osmond gave his Guernsey property and entire collection of books to the people of Guernsey so that a Free Library could be founded. The Priaulx Library continues to thrive today.

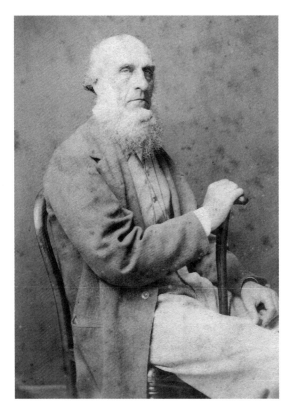

Osmond de Beauvoir Priaulx (1805–91), barrister and philanthropist, and youngest son of Anthony Priaulx.

5
ENTREPRENEURIAL ISLAND

Guernsey people are survivors; they are practical, hard-working and, as has been said of them a time or two, rather fond of making money. The relative isolation of the island (historically at least), plus the uncertainty of the sea and the weather and relying on imports for more than the bare necessities of life, has not surprisingly engendered an eye for seizing opportunity when it is offered. When Victor Hugo came to live in the Channel Islands in 1852, he was quick to notice the industriousness of the people that lived there. In *L'Archipel de la Manche* he wrote, 'There is a hard-working human anthill on the islands. The work of the sea, which brought destruction, has been replaced by the work of man, which has created a people.'

Hugo saw the landscape as the force that moulded the character of the islanders. This character is less in evidence today perhaps, but can still be seen. For example, Guernsey's west coast is awash with little cottages, which once housed the 'typical Guernseyman' – stubborn, independent and taciturn, with the sea in front of him and the vegetable garden behind; perhaps a cow or a goat for milk and grazing, and a little patch of sweet peas, living on the margins, both literally and figuratively. Any excess produced from the land might be sold on hedge or gatepost – a little more money never went amiss. There are fewer Guernseymen of this sort left in the twenty-first century, but the independent spirit and determination still exist in abundance.

Guernsey's major industries over the centuries are well documented. Quarrying, tomato growing, tourism and international finance – all of these have been, or still are, enormously important to the security and economy of the island. Their rise and fall have been the source of great wealth or great distress, but like a many-headed hydra, cutting off one source of income merely makes way for another, and in this pragmatic and opportunistic way Guernsey has survived the years.

This chapter is intended to provide a flavour of that entrepreneurial spirit, and also to look a little more in depth at some of the distinctly odd and quirky economic opportunities grasped. From a knitting industry in an island that produced no wool, to burning seaweed, and to growing tropical fruit, the island has certainly tried out many ideas – some more successfully than others.

The Rise and Fall of the Major Industries

Quarrying is written about in some detail in the third chapter of this book, but it is worth pointing out that although the development of the stone industry in the nineteenth century is a classic example of Guernsey people exploiting their own environment, the industry did not become significant economically until social and political conditions made it a viable option. Local granite had always been used domestically to build houses

Above: Typical Guernsey cottages, poised between the sea and the land.

Left: 'Hedge Veg' still thrives in Guernsey where home-grown produce can be bought for a fair price. The money is put into the honesty box.

and walls, but quarrying on an industrial scale did not begin to occur until the late eighteenth century. At first, the extent of the quarries and the skills of the stoneworkers focused on increased domestic need. This led to the extension of the pier at St Peter Port in the 1750s, the paving of roads and the building of the New Town late in the century, and finally the need to improve the island defences with a series of loophole towers around the coast. In the early nineteenth century, the creation of new military roads increased both stone production and the labour force imported to work the stone. A new industry was born and it became extremely profitable to start exporting stone to other countries, particularly for road surfacing.

In such ways is Guernsey tied to social and economic change. The tourism industry similarly developed at the same time that the concept of leisure time became a social norm in the late nineteenth century. Much like beach resorts around the south coast of England, Guernsey sought to exploit its natural beauty and temperate climate while taking advantage of increasing and cheaper travel to forge a new industry. Tourism became a mainstay of the Guernsey economy throughout most of the twentieth century.

At its height, tourism corresponded with the development of the tomato growing industry. So vital and all-consuming was tomato production, the island and the fruit became almost synonymous and even today, thirty years after the industry's decline, the 'Guernsey Tomato' is still remembered. Tomato growing was certainly not inevitable; Guernsey does not have the climate to grow the plants outdoors for instance. However, Guernsey did possess a vast expertise in a very niche market, and it is this above all else that made the tomato industry so vital. In the mid-nineteenth century, when tomatoes first became popular comestibles, Guernsey was already producing a lot of grapes for export. By planting tomatoes at the foot of the vines, the growers discovered they could double their production without increasing their space and an industry was born. Intensive greenhouse production became the norm, and by the 1970s and '80s, Guernsey was a sea of glass. In 1980, Guernsey supplied a full 25 per cent of the 200,000 tons of tomatoes consumed in the UK.

None of these important industries deserve to be dealt with so abruptly, but they are well documented elsewhere and here serve as an illustration of the cycles of boom and bust that have affected Guernsey over the last couple of centuries. It was

DID YOU KNOW THAT...?

Tourism marketing for Guernsey in the mid-twentieth century made much of the yearly 'sunshine hours'. With a more temperate climate than the UK (more than a degree centigrade warmer on average), it was implied that coming to Guernsey was like going abroad but cheaper, and where people spoke English! An article in The Times on 23 December 1931 declared that Guernsey had maintained its record as the sunniest place in the British Isles over a thirty-seven-year period. In 2000, the Guernsey Met Office reported a thirty-year annual average of sunshine with 1,820 hours – a full 465 more than the UK's 1,355 hours.

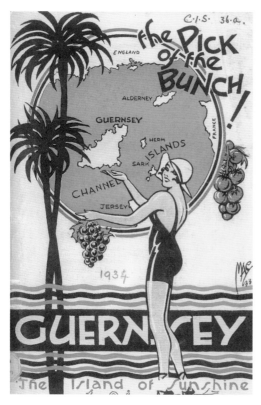

Left: A brochure advertising Guernsey in 1934. Notice the bunches of grapes and tomatoes – both important exports of the day.

Below: Guernsey tomatoes on display at Barrow's vegetable stall in Birmingham in 1969. (*Photograph by the Guernsey Tomato Marketing Board*).

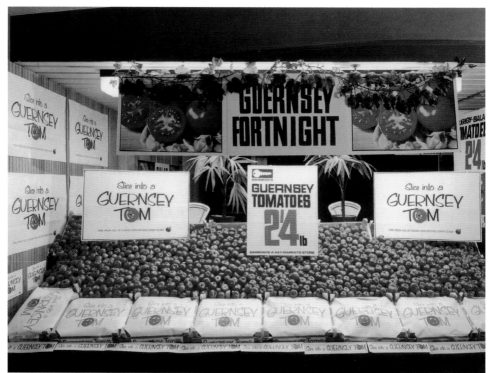

the threat of cheaper exports from elsewhere that destroyed both the stone and the tomato industries, and such things are inevitable in a competitive economy. There is no doubt either that tourism has declined significantly now that the world is a smaller place. Families travel further afield these days and Guernsey, sunshine hours notwithstanding, is relatively expensive because of that. There is a future for tourism in Guernsey, but it needs to rebuild the infrastructure to meet the leisure needs of the twenty-first century. The phoenix from the ashes of these industries has been finance – banking, fund management and insurance. The finance industry today employs 20 per cent of the workforce and accounts for 37 per cent of the island's GDP. Will this industry also stand the test of time? What is certain is that Guernsey will continue to adapt and change as global forces dictate.

Some Industrial Oddities

Guernsey's entrepreneurial spirit has taken some varied directions over the generations. Sometimes the new industries exploit a natural resource, use a native skill, or just take swift advantage of an economic opportunity. One does not immediately associate Guernsey with underwear, but in the seventeenth century Guernsey's knitted stockings were of such quality that they were worn by Queen Elizabeth I herself, and it is said that her unfortunate cousin, Mary Queen of Scots, wore a pair of white Guernsey stockings on the morning of her execution in February 1587. They were therefore luxury items and were prized for their quality. Unfortunately, little is known about how or why the trade in knitted garments happened, but it is in some degree odd that Guernsey was so successful in manufacturing a product from a raw material that had to be imported. Guernsey is far too small to be viable for wool production.

Wool was certainly being imported in the late 1470s from Poole, and it is known that many Guernsey families were involved in the trade, particularly the de Havilland and Henry families. The stockings were made in a variety of styles and colours. Most of the designs are now lost to time, but it is known through correspondence that one of the most popular ranges were green-and-white stripes. It was literally a cottage industry in which mainly women and girls worked all hours of daylight from home over their needles.

DID YOU KNOW THAT...?

The 'Guernsey' is one of the most practical garments you are ever likely to find. It is rain and salt-spray resistant, warm and practically indestructible. It is no surprise, therefore, to find them appearing in a variety of guises around the world. The Guernsey is part of the official RNLI uniform and they are often ordered by the British armed forces in regimental colours to be worn in colder climates, such as Afghanistan. The Royal Navy use them and, in 1985, the America's Cup crew had Guernsey's especially made for their crossing, as did the British three-day eventing team in the 1979 European Championships.

A relic of Guernsey's growing industry – an abandoned greenhouse and the chimney for the furnace that heated it.

The trade began to decline in the eighteenth century, and it was, inevitably, the social and political situation that saw the end of the stocking trade. A majority of the exports of stockings were to France, but the French Revolution and Guernsey's involvement in the Napoleonic Wars through the licensed privateers, put paid to all legitimate trade. Domestically, the knitting tradition continued in the production of the knitted 'Guernsey' or 'Gansey' – pure wool, close-fitting and almost weatherproof garment, much beloved by fishermen and other outdoor workers. These are still made on the island today.

If knitting prospered because of native skill and hard work, the production of iodine in the nineteenth century came about due to a quirk of the natural environment. As early as 1846, the proceedings of the Chemical Society received a presentation regarding Guernsey kelp. Traditionally, seaweed (particularly bladder wrack), which was known as *vraic* in the native tongue, was collected from the beach, dried, and burned as fuel or fertilizer. This was a right for all Guernseymen, and the right is still in force today. In 1846, the president of the Chemical Society had found the Guernsey kelp to contain more iodine than ordinary kelp as it came from deeper waters, and he drew the attention of manufacturers towards this fact as a potential source of future profit '... with the present high price of that drug'.

Iodine had been discovered by Bernard Courtois in 1811 and it was found that a tincture of iodine was a very powerful antiseptic. The element was therefore in great demand until alternatives were found in the mid-twentieth century. The extraction of iodine from kelp involved burning the seaweed, washing the salts out then treating the residue with

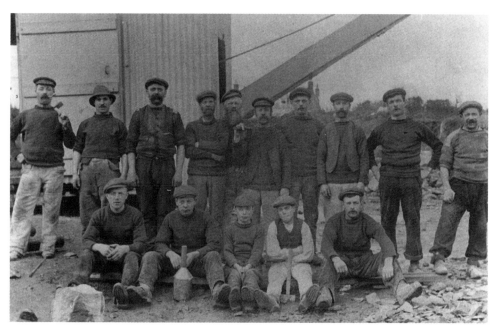

Nineteenth-century quarry workers wearing their traditional woollen Guernsey jumpers.

sulphuric acid. The iodine was released as a purple vapour, which condensed into crystals that could then be diluted with water or alcohol. Not a particularly easy process, and as an industry, required a lot of water from a consistent supply.

Despite the abundance of suitable seaweed, iodine production did not begin in Guernsey until the 1880s, by which time the enterprising Albert Best had purchased the Steam Mill in Le Douit de la Porte in St Martin's, which was situated in a valley below Ozanne's Windmill. The steam mill no longer exists, but the road is now known as Steam Mill Lanes. Many local families were employed to gather vraic, dry it and burn in their front gardens. It was only then that the ash was taken to Steam Mill Lanes for processing. By far the largest supplier of the dried and burned seaweed was the tiny island of Lihou, off Guernsey's west coast. This island is only 36 acres and is only accessible at low tide, and not at all during a neap tide. In the late nineteenth century, the island boasted a ruined medieval monastery and a single house that had been built by James Priaulx of Montville in the 1870s. The garden of the house became a large seaweed drying area, and great clouds of smoke from the burning of seaweed could be seen from the Guernsey coast half a mile away.

The iodine industry went the way of so many other entrepreneurial ideas when cheaper alternatives became available in the 1930s, but there is no doubt that when the history of the Guernsey industry is examined, it will be known that the island has always found a way to survive losses and continue to prosper.

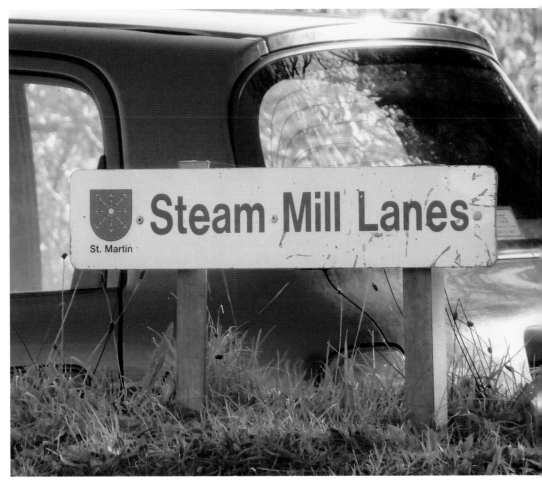

Steam Mill Lanes. The steam mill processed chicory before it was purchased by Albert Best for the production of iodine.

DID YOU KNOW THAT...?

In the 1860s and '70s, Guernsey was one of the largest centres for marmalade production in Europe. Sugar tax in Guernsey amounted to around 2s per 2,000 lbs of sugar – a fraction of what it was in Britain. In seeking a better share of the market, the Dundee marmalade manufacturer James Keiller & Son moved their centre of operations from Scotland to Guernsey and, as a result, were able to undercut all their rivals and make a huge profit. Their factory in Park Street employed around 200 local people. In 1879, after twenty years of production, the reduction in sugar duty in Britain signalled an end to the Guernsey branch of operations, and the company disappeared as suddenly as it had arrived.

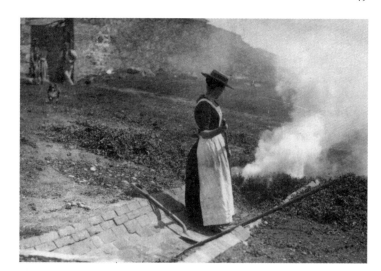

Vraic being dried and
burned outside Lihou
Island house in 1895.

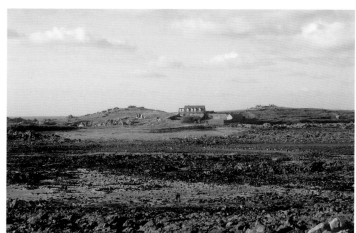

Lihou Island today.

Keiller's marmalade
factory in Park Street in
the 1870s.

6
FOLK MAGIC

One does not need to scratch the veneer of civilisation in Guernsey very deeply to find the pagan origins beneath. Island communities have more than their fair share of tales of magic, hauntings, witchcraft and superstition – possibly because the people have traditionally had more marginal lives, dependent on the sea and elements for their livelihood, but in danger from them too. The shoreline becomes a symbol of this dichotomy – the gateway between life and death, the known and unknown. Victor Hugo summed this up nicely in his preface to *Les Travailleurs de la Mer*, when imagining the Channel Islanders' forebears: '... they recognised two seasons only in the year – the fishing season and the shipwreck season'.

Out of this uncertainty grew a rich tradition of folk tales, magic and ritual. The phenomenon has been written about in some detail by social historians such as de Garis and MacCulloch, but there are still one or two tales that are less well known.

Bad Books

Les Mauvaise Livres (The Bad Books), *Les Livres de Diâble* (Books of the Devil) and *Le Grimmaille* (The Grimoire) – there are many names for these little tomes. They are *Le Grand Albert* and *Le Petit Albert* – two small books published in large numbers in the eighteenth century, professing to contain secrets and marvels. To today's eyes, they are relatively innocuous, but they acquired an evil reputation in Guernsey for a number of historical reasons.

The religious and political upheaval of the sixteenth and seventeenth centuries throughout Europe ushered in a period of witch trials and executions. In Guernsey, this was particularly true, partly because of the tension between Catholics and

DID YOU KNOW THAT...?

A *Grimoire* (from the latin for 'Grammar', i.e. 'knowledge') is a textbook of magic – an instruction manual on how to perform spells and rituals, and most importantly, how to summon demons or the Devil himself. The Priaulx Library has a number of Grimoires in its collection, including the notorious Grand and Petit Albert, but also a number of other works including the *Occulta Philosophia* by Henry Cornelius Agrippa, who became known (rather unfairly) as 'the most evil man in Europe' because of this early belief in the supernatural and occult. Many of the books in the collection were owned in the eighteenth century by the Allez family of Les Bordages in St Saviour's, but the reason the family had for owning them remains a mystery.

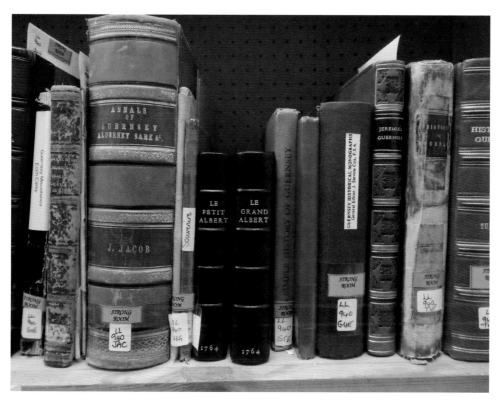

Le Grand Albert and *Le Petit Albert* at the Priaulx Library.

Protestants pre- and post-Reformation, a number of years of poverty, failed harvests and, later in the period, the political tensions of the Civil War when Guernsey stood for Parliament and her sister isle – Jersey – stood for the Royalists. Guernsey witch trials took place from 1550 to 1649, during which time over thirty so-called witches and wizards were executed, usually by hanging followed by burning. An equal number were banished from the island.

These sorts of acts demonstrate the seriousness with which the supernatural was treated by Guernsey authorities. In subsequent centuries, the memory of this, coupled with a strong puritanical streak in Guernsey Protestantism, had the effect of enhancing superstition rather than reducing it. *Le Grand Albert* and *Le Petit Albert*, first mass-published in France in the 1760s, were widely available and among the most popular of Grimoires on the continent. In an insular society with poor literacy, the written word had an almost magical significance and even the mere fact of possessing both or either of these books induced an awe and fear in others far outweighing the quality of their content.

So what were these books precisely? *Le Grand Albert* was purported to be the work of a thirteenth-century monk, saint and philosopher called Albrecht de Groot (Albert le Grand in French). Due to Albert's interest in the odd and esoteric, he gained a reputation as a great sorcerer, and strange and wonderful magic was associated with him. He was

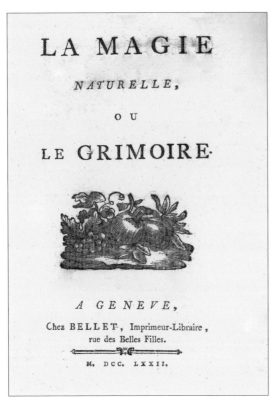

One of the Grimoires in the Priaulx Library collection.

supposed to have held the secret of the Philosopher's Stone, and had even allegedly created an automaton with great knowledge that he called an 'Android'. The contents of *Le Grand Albert* are not quite this startling, and it mainly contains essays about human physiology (including a large section on gynaecology) and rather benign information on physiognomy and astrology.

Le Petit Albert, by contrast, was a cobbled-together affair mainly written by ambitious publishers, or plagiarised from other sources in an attempt to cash in on the relative success of *Le Grand Albert*. It was first published in 1668 and contains a variety of 'spells', talismans, rituals and folk remedies. Some of the spells are rather darker than others, such as instructions to make the fabled 'Hand of Glory', which is the left hand of a hanged man converted to a candle and used to divine for buried treasure.

Quite why these relatively innocuous books attained the reputation they did in Guernsey is probably due to the fear of parish priests that their congregation, in owning such things, were not taking religion with sufficient seriousness. Owning one of these books was both a blessing and a curse – the owner was imbued automatically with great power, but once owned they were practically impossible to be rid of. Fire did not touch them, and simply throwing them away guaranteed that they would be returned the following day by forces unknown. This curse was thought to be induced merely by touching them, and it is still possible to find Guernsey people today who would think twice before handling *Le Grand Albert* and *Le Petit Albert*.

Le Grand Albert in its 1764 edition. The first French edition of the book was in 1651.

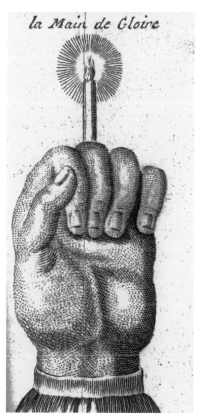

'The Hand of Glory' from *Le Petit Albert*.

Concealed Objects

We move now from written spells to a strictly oral tradition of folk magic. The phenomenon of concealed objects, i.e. objects deliberately concealed in the chimneys, staircases or under/over the doors and windows of buildings, is one that is found throughout the world and particularly in Northern Europe. These objects are usually revealed when properties are renovated or demolished and one never knows when they might turn up, so it is worthwhile keeping an eye on your own house, particularly if it was built before the twentieth century!

In Guernsey, it is not uncommon to find horseshoes and nails in chimneys, or several ormer shells (the ormer, a type of abalone, is a rare and prized seafood delicacy) carefully concealed. Iron, such as that found in the nails of horseshoes, was supposed to be painful to witches. Often, if a single object is found rather than a collection (a 'cache' is the official term), it will be an old worn boot or a tattered item of child's clothing. Several discoveries of this type made in the last ten years have been documented by the Priaulx Library.

But what do these items mean, and why are they concealed? J. G. Frazer, in his famous work *The Golden Bough*, suggests that worn clothing is ideal for the practice of 'Sympathetic Magic' wherein the essence and intention of the wearer is somehow absorbed and retained by their garments. Of course, the more worn the clothing the stronger the magic, which is why new items are almost never discovered. The boot, shoe or item of clothing once concealed then represents the presence of a person, which then provides protection against intrusion in the most vulnerable parts of the house – the chimney, doors and windows. They were not guarding against human intrusion, though, but warding off evil spirits, poltergeists, witches and curses.

Occasionally, a larger cache is found than just a single garment. In 2005, a carpenter working on repairs to the roof of the Priaulx Library discovered a collection of 'rubbish' hidden in a gap between the joists below the central roof window. He initially put it all in a bucket intending to throw the bits and pieces away until he realised that the odd variety of objects implied their placement was deliberate rather than accidental. Among the collection was a hob-nailed boot, a broken china dish into which the letters 'VV' and 'VM' had been scratched, a glass fragment that had an eye drawn on it, a metal pot lid, part of a buckle from a pair of men's braces and a clay pipe.

DID YOU KNOW THAT...?

It is difficult to find information about concealed objects because the practice was a secret one mainly confined to the workers in the building trade, and would have been an oral tradition handed down through the generations. Most of the objects in the Priaulx Library cache dated from 1885–86, which was when renovations took place on the building. Coincidently, in 2003, a piece of panelling was found with a number of names pencilled on the back dated 1886 – names of the workmen who did the renovations. It is likely that the foreman, Pierre Bougourd of St Martin's, was also the one who concealed the objects in the roof.

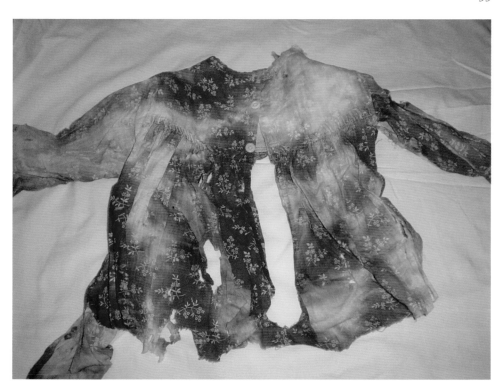

A tattered child's dress found bricked up in a wall in a house in the Forest parish.

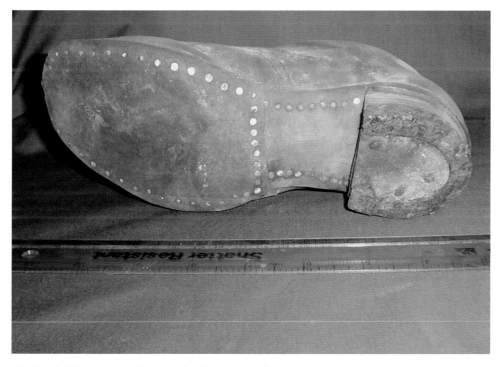

A hobnailed boot – part of the Priaulx Library cache found in 2005.

The clothing and household objects provided the 'sympathetic magic' protection, but obviously the concealers thought that stronger protection yet was required. The 'VV' and 'VM' are known as apotropaic marks (from the Greek *apotropaios*, literally 'repelling evil'). The marks invoke the Virgin Mary (or Virgin of Virgins). The eye drawn on the glass is easier to understand – it is a direct defence against the 'evil eye'.

The next time you renovate your house and find some odd objects hidden under floor boards or in chimneys, don't assume they are rubbish and throw them away – you may be removing supernatural protection! Once the Priaulx Library cache had been properly studied and documented, it was placed in a specially made box with one or two modern items added, and returned to its hiding place. Better safe than sorry.

St John's Eve

Magic in the form of the written word has been mentioned as well as a secret ritual from the oral tradition. Now we can mention a third type of ritual, not secret or hidden, but a community folk tradition that took place on St John's Eve. St John's Eve is the evening of 23 June – the day before the celebration of the birthday of St John the Baptist. This was a traditional night for revels in Guernsey – revels that had much in common with traditional pagan midsummer celebrations, since the summer solstice was often very close to St John's Eve. Throughout Europe, the custom was for lighting bonfires on hilltops, but the pre-eighteenth-century Guernsey people combined this tradition with several other interesting rituals centred upon La Rocque Balan – a natural rocky outcrop that seems to have had some sacred significance.

La Rocque Balan has a number of important attributes. It rises high above the flat common land around it, and commands magnificent views of the north of the island. It has an even flat area on top of it, which allows for a gathering of people, and it has two depressions in the top which appear far too symmetrical to be entirely natural. It is indeed likely that these depressions are natural, but they are remarkable enough that there is still some debate on this issue, especially since one of the depressions seems darker, as though scorched by burning.

The name *Balan* appears to come from the Biblical *Baal* or *Belus*, referring to a deity, but is just as likely to have the same root etymologically as the Gaelic *Beltane* or May Day Festival, from the Proto-Indo-European *Bhel* (burn) and Old Irish *Ten* (fire). Whichever is correct, there is a link to ancient rituals. Antiquarians of the eighteenth and nineteenth century used to get very excited about the possibility of Druidic activity in Guernsey, and on this tantalising rock in particular. The round depressions in the top conjured up terrible images in their fevered imaginations, and suggestions of human sacrifice were not uncommon. This poem from 1830 amply demonstrates this:

> Here on the plains of grief our fathers stood
> Round BALAN's altar-graves, and called him GOOD!
> With shouts of rapture drown'd each victim's breath;
> And laugh'd, or trembled, at the scream of death.

DID YOU KNOW THAT...?

There is a lovely fictional description of the Guernsey St John's Eve celebrations at La Rocque Balan in *The Little Gate of Tears*, a novel by Austin Clare, published in 1906. There, heroine Denise Tourtel accompanies her suitor, the Jerseyman Gaston Le Patourel, to L'Ancresse Common to take part in the dancing and to sing the ancient Guernsey song:

> ...the mad dance began again. The fiddles played their fastest. The young men shouted, and the girls sang aloud the time-worn burden of the ancient songs – *Irons tous à la Fête Saint Jean, Dansaîr sus la Rocque Balan.*

The place where the concealed objects were found (and returned to) at the Priaulx Library.

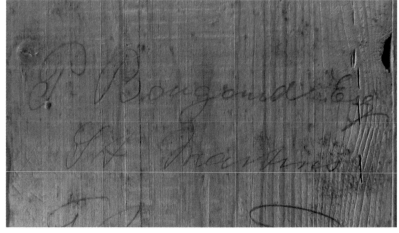

Pierre Bougourd's name pencilled on the back of a piece of panelling.

La Rocque Balan on the edge of L'Ancresse Common, Vale.

The depressions on the top of La Rocque Balan that have been the subject of much discussion.

In reality, the rituals that took place at La Rocque Balan on St John's Eve were much more innocent and benign. The folklorist MacCulloch describes how young unmarried people would gather on the top of the rock, light a bonfire and dance on its summit – in effect an interesting way of meeting a future spouse. Marie de Garis relates that when the young people walked to the rock they carried conch shells and brass bowls that they would blow and bang to ward off evil spirits. This is much more like Beltane celebrations than imagined Druidic rituals.

Folk magic takes many forms and, although it is almost never seen in modern times, evidence can still be found in libraries, folk stories and in the landscape.

View from the flat top of La Rocque Balan.

7
REMEMBERING ROYALTY

Even a casual glance through a Guernsey guidebook or local map will quickly show up quite a high number of streets, places and objects named in honour of Great Britain's longest reigning monarch. There is Victoria Road, Victoria Avenue, Victoria Pier, the Victoria Marina, Café Victoria (which is overlooked by the Victoria Statue), Victoria Tower, Victoria Terrace and The Queen's Road. Queen Victoria's husband is also represented, although not so prolifically, with the Albert Statue, the Albert Pier and Prince Albert's Road. Apart from an occasional George, Victoria is the best represented monarch on the island. Why did Guernsey go Victoria mad? The answer lies in the events of 24 August 1846.

A Royal Visitor

At 18.00 p.m. on Sunday 23 August 1846, a military look-out spotted a small flotilla of ships off St Martin's Point to the south west of Guernsey. As they approached, it quickly became clear that this was no ordinary encounter. There were four ships in total – the Royal Yacht steamers *Victoria & Albert* and *Fairy*, and Her Majesty's steamers *Black Eagle* and *Garland*. Above the *Victoria & Albert*, the Royal Standard was flying. Knowing what this meant, the soldier sent an immediate message back to Fort George so that when the squadron of ships came to anchor in the Roads, the guns of the fort fired a Royal Salute. By 19.30 p.m, Lt-Gov. Napier, Maj. Goodman of Fort George and Utermark, the solicitor general, were already on their way in the boat to the royal yacht. News spread quickly and, as the sun set, the whole of the seafront and the houses rising up the hill behind became illuminated as everybody lit lanterns, torches and fires.

DID YOU KNOW THAT...?

Royal visits to Guernsey had been in very short supply before Queen Victoria's visit in 1846. Records state that Prince Edward, later Edward I, was appointed Warden of the Isles in 1254, but although he would have had an income from the islands there is no record of him having visited. Another Edward – Edward IV – when Earl of March, is said to have escaped to France via Guernsey after the Battle of Ludford Bridge in 1459. Finally, Charles, Prince of Wales, later Charles II, spent some time in Jersey during the Civil War, but he never visited Guernsey – wisely, as Guernsey was on Parliament's side!

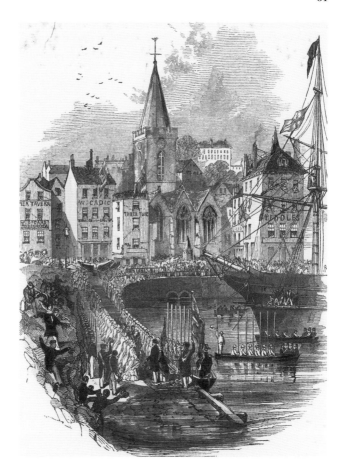

An illustration by Paul Jacob Naftel showing the visit of Queen Victoria and Prince Albert, and published in the *Illustrated London News*.

The enthusiasm for the Queen's unexpected visit was strong and genuine. In the early years of the nineteenth century, Guernsey's relationship with the United Kingdom had at times been strained – partly due to wrangles over smuggling and customs duties. In addition, the lieutenant-governor, Gen. Napier, was extremely unpopular on the island and his high-handed behaviour and contempt for the local government was obvious. He had appealed to Queen Victoria for help when he believed that the Guernsey population was going to oust him by force, which caused so much outrage on the island that the Royal Court proclaimed the loyalty of the islands to the Crown. The visit in 1846 was therefore seen as a tacit acceptance of Guernsey's loyalty. *The Star* newspaper wrote, '... the present happy occasion will be made use of for bringing into oblivion all existing disagreements, and of restoring to Guernsey that peace and union of which it has been so long deprived'.

Queen Victoria landed on Guernsey soil at 9.00 a.m. the following morning, and then went on a short carriage tour around St Peter Port and St Martin's before returning to the royal yacht before 11.00 a.m. Short as the visit was, and made with little notice or ceremony, the population of St Peter Port managed to bestir themselves to line the streets and welcome the royal couple with colourful displays:

... she alighted from the boat ... she walked between the files of ladies leaning on the arm of Prince Albert, both most graciously smiling and bowing – the ladies threw flowers and curtsied low as she passed us, so that the carpet was strewn with flowers, the band played the national anthem ... the dear old church bells were ringing merrily. It was a proud day for us all.

The national pride felt on the visit translated itself into a flurry of commemoration. Within days, letters to the newspapers were demanding a public memorial and a committee was formed to accept public subscriptions. As an interim measure, a stone was laid to mark the spot at the harbour where the Queen had alighted. A road called Le Petit Marché, along which the Queen had travelled in her carriage on the way to view the soldiers at Fort George, was renamed The Queen's Road. The road sign, still prominent today, proclaims the date of the historic visit. An adjacent road, Pierre Percée, was renamed Prince Albert Road.

Victoria Tower

At a public meeting in the autumn of 1846, the Victoria Tower Committee was formed to raise money to build a suitable edifice. The committee appointed the States of Guernsey as the project managers – an early example of a public/private partnership – and public subscriptions immediately invited. The states, as befitted their administrative

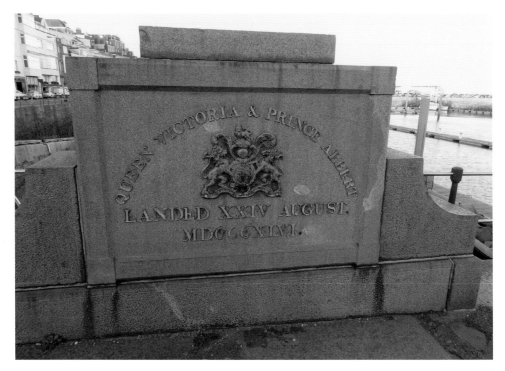

The stone at the harbour, commemorating the spot on which Queen Victoria and Prince Albert landed in August 1846.

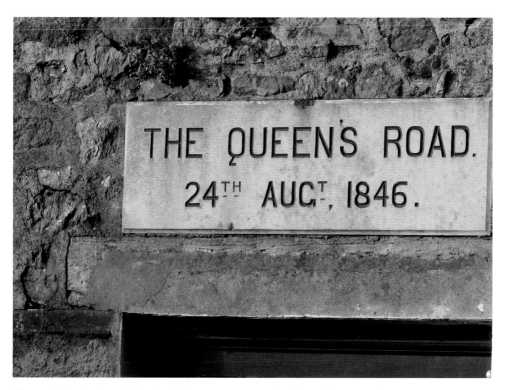

The road sign in Queen's Road, which commemorates the date of the Queen's visit.

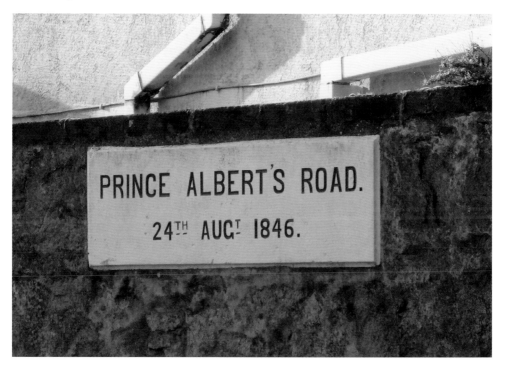

The Prince Albert Road sign in the adjoining road.

role, advertised in local and national newspapers for architects to submit plans for consideration, working to a budget of £1,500. It was believed that sum would quickly be raised through donations and the budget was eventually raised again to £1,800. The design chosen was a gothic, highly decorated tower by William Bunn Colling (1813–86). Colling had practiced in London, but was not particularly prominent as an architect. Victoria Tower is his best-known work, in addition to the Grade II listed Hendrefoilan House in Swansea. He was the brother of the better known James Kellaway Colling, who had come to prominence in the late 1830s with a book on Gothic ornamentation and was responsible for the Albany building in Liverpool. William must have taken a leaf out of his brother's book for the Gothic appearance of the elaborate crenellations and stone 'coronet' at the apex of the tower.

The laying of the foundation stone was a great event on 27 May 1848 (Queen Victoria's twenty-ninth birthday) and was attended by all the island's great and good. Despite the elaborate plans and public enthusiasm, the Victoria Tower Committee failed to raise all of the money required and were forced to appeal to the states for funds. The final cost was around £2,000 and the contractors were not fully paid until the mid-1850s. Due to the delay in payment, although the tower was completed, the site was not cleared and was left looking very untidy and unloved. In a letter from 1853 published in *The Star* newspaper, a resident complains of the piles of stones and the almost impassable road, calling the area 'a complete miniature Stonehenge'.

Luckily, by 1859 the area had been cleaned up as Queen Victoria and Prince Albert visited for a second time in the August of that year. They inspected the new tower, giving it the royal seal of approval.

A Royal Death

In December 1861, only two years after the royal couple visited Guernsey for the second time, Prince Albert died. He was only forty-two and the Queen was plunged into deep mourning. Guernsey was certainly not alone in planning memorials to the departed consort as many sprang up around the British Isles in the following months. In Guernsey, within the space of a few weeks, Charlotte Slade, the wife of Lt-Gov. Gen. Slade, put up a memorial plaque at the site of a tree she had planted in 1859 to celebrate the second visit of Queen Victoria and Prince Albert, which still stands today. The major commemoration of the Prince Regent, however, was to be a statue. In a similar model to

DID YOU KNOW THAT...?

Victoria Tower is built of pinky-orange 'Cobo granite' mined from the Rocque du Guet in the parish of Castel. Often known simply as 'pink granite', the stone is technically a granitic rock known as adamellite. It is well loved for its unusual colour and was popular for public buildings, but it is a particularly hard stone and difficult to dress for decorative effect.

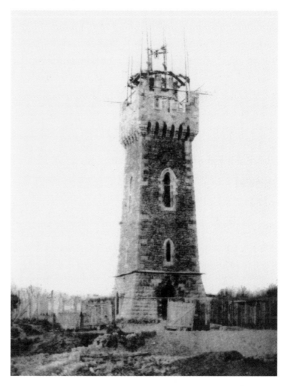

Victoria Tower under construction in 1848.

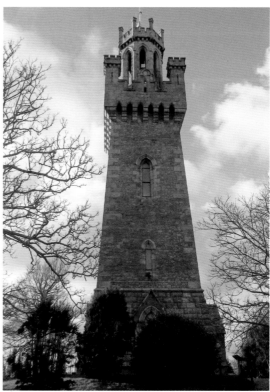

Victoria Tower taken from Monument Road, which was given its name after the tower's construction.

The Victoria Tower commemorative plaque.

the Victoria Tower Committee fifteen years earlier, a Prince Consort Statue committee was formed to take public subscriptions. This time around the money was quickly and easily raised. In fact, a 'Momento' poster, published in 1863 as an official thanks to the subscribers and organisers, lists more than 900 donors. The total raised was more than sufficient to cover the £800 cost of commissioning the statue, and allowed a fine Cornish stone plinth to be fashioned, raising the statue high above the ground and dominating the prospect of the quayside.

The statue is a direct copy of Joseph Durham's fine statue of Albert, first cast in bronze to celebrate the Great Exhibition of 1851 and which now stands behind the Royal Albert Hall in London. The Guernsey version is a full-size copy showing the Prince in the regalia of the Order of the Bath, although the bronze is now somewhat discoloured by age and sea air. He is well worth a viewing and is to be found a stone's throw away from the stone that marks the spot when he first visited Guernsey in 1846. Now the pier where the couple landed is known as the 'Albert Pier'.

The Diamond Jubilee

When it came to royal commemoration, it appears that the Guernsey people had formed a pattern. As with previous occasions, a public meeting decided on a scheme, which public subscriptions paid for. For Queen Victoria's Diamond Jubilee in 1897, a statue of the monarch was chosen. It was to be a copy in bronze of a well-known statue by C. B. Birch. In total, £730 was collected and the statue commissioned from the foundry of Hollinshead and Burton of Thames Ditton. A. C. Andros, a Guernsey engineer, entrepreneur and occasional raconteur, attended the forging of the statue on 21 July 1898 and wrote about

DID YOU KNOW THAT...?

The Queen Victoria Statue is a copy of a bronze by Charles Bell Birch (1832–92), which he first sculpted from life just before his death in 1892. The original stands at Blackfriars Bridge in London, but copies can also be found in Aberdeen, Newcastle-under-Lyme and Adelaide. In December 2014, the Candie Gardens statue was cleaned by a specialist bronze restorer so it looks as bright and fresh as the day it was unveiled.

the event at length in *The Star* newspaper. He was impressed by the delicacy of the work: 'strong steady hands poured the molten metal for several minutes with as much ease and regularity as water poured from a jug...'

Andros was disappointed that the Victoria Statue was not to be erected along the seafront near the statue of her late husband, but at the top of Candie Gardens high above St Peter Port, 'where none will see it'. This is certainly not the case today.

The unveiling of the statue did not take place until 1 March 1900 – some time after it had been forged. The ceremony was much less grand than the great event that occurred at the unveiling of the Albert Statue, and in fact many of the subscribers had not been informed that the unveiling was taking place. The reason given was that the unveiling had been organised and carried out in great haste as a commemoration of the relief of Ladysmith, which had happened that very day.

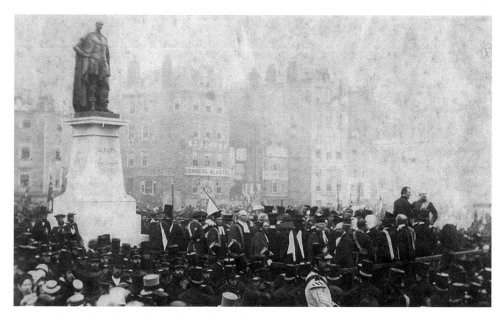

Inauguration of the Prince Albert Statue in October 1863.

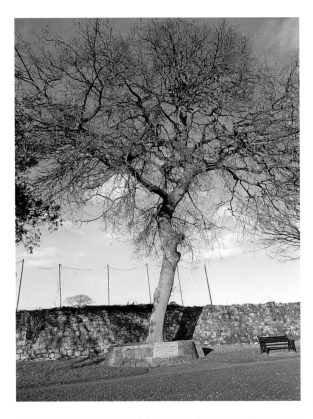

The tree planted by Mrs Slade on the second visit of Victoria and Albert in 1859.

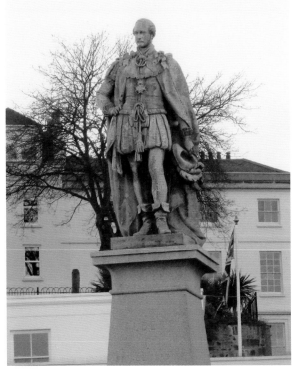

The Prince Albert Statue by the Sculptor Joseph Durham.

The Queen Victoria Statue pictured in January 1901, shortly after the monarch's death.

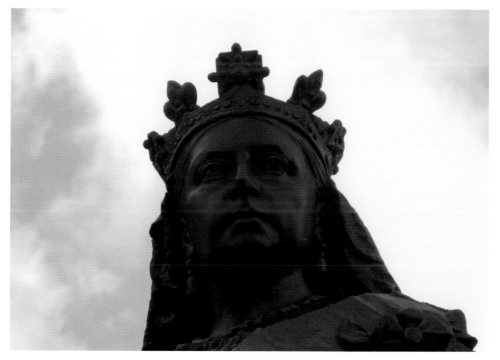

A detail of the Queen's face on the recently restored statue.

8
WHAT'S IN A NAME?

Surnames

The unwary traveller in Guernsey might quickly become confused or disorientated by the odd, exotic and contradictory road, place and family names. A single road might be known by three different names; a direction to a road might be given in French or English, or a hybrid of both. A surname might be spelt in the English fashion, but pronounced in the French fashion, or even pronounced differently in different parts of the island. There are so many pitfalls it is a shame that first-time visitors to the island are not provided with a guide.

Even the name of the island itself has changed in various ways over time and its first naming (if such a thing can ever be calculated) is a matter of some contention. The Channel Islands are first listed by name in the Antonine Itinerary of the third century, but deciding which of the names was meant for Guernsey has been troublesome. Most scholars agree that 'Lisia' or 'Lesia' was Guernsey and 'Sarmia' was Sark. However, after centuries of mistakes and misunderstandings, 'Sarmia' (which eventually changed to 'Sarnia') became the preferred name, and is used today as a fanciful and poetic alternative to the more prosaic 'Guernsey'. It is best known in Guernsey's unofficial national anthem 'Sarnia Cherie'. From the tenth century onwards, the island was known as by many and varied forms of 'Grenesey', 'Gernesoy', 'Gernerui', 'Grensey' and 'Garnsey' with 'Guernsey' becoming the most consistent spelling by the end of the nineteenth century. What 'Guernsey' actually means is also open to debate, but may derive from the old Scandinavian languages and mean 'green isle' or something similar.

One of the more immediately noticeable Guernsey aspects, when viewing the local telephone directory, are the number of 'French' surnames, which reveal much about the Norman origins of the Channel Islands. The Channel Islands were part of the Duchy of Normandy from 911 until the Duchy was lost to the English Crown in 1204 and the islands elected to stay under English control rather than French. It was during this period that surnames became both commonplace and inheritable, so it is no surprise to find so many old Norman surnames abounding – names such as Brouard, Lenfestey, Le Poidevin, Roberge, Ozanne, Blondel and Brehaut. A quick calculation shows that the most common Guernsey surname is Le Page, outnumbering the Smiths by about 80 per cent.

The distribution of names in Guernsey in the twenty-first century is of course much more cosmopolitan that it was generations ago, reflecting the vibrant social mix of people from all over the world who have come to work in the finance, health, building and tourist industries. Names are social history, and names that are well established now tell us much about Guernsey's industrial past. For example, from the South West of England came the names Dimond, Frampton, Inder, Tozer, Pengelley and Luxon in the early nineteenth century – families coming to the island to seek work in the stone industry and other trades, who married and stayed. Later in the century, from France, came families such as Audoire,

'Sarnia Cherie', the popular Guernsey song, featuring the poetic (but incorrect) name for Guernsey.

Baudain, Desprès, Le Goupillot and Trouteaud, also seeking work the names settling in quietly alongside the older Norman-French native names.

Old Guernsey surnames have also made their way into place and road names throughout the island – places that were once their family estates, but of which evidence only survives through the names. As so many of these surnames are extinct, some of the road names below may come as a surprise to islanders. La Gibauderie, a road in St Peter Port, is named after the Gibaud (or Gibaut) family. One Marthe Gibault was the great-grandmother of Anthony Priaulx who features in a previous chapter. Rue des Bailleuls, a long narrow lane in St Andrew's, was named after the Bailleul family who were numerous and wealthy in the sixteenth and seventeenth centuries. Rue des Eturs, a main road in Castel, was named after Nicholas Etur (born *c.* 1530), a merchant and ancestor of many important Guernsey families, including Bonamy, Le Cocq and Gosselin. Les Vauxbelets is a beautiful valley in St Andrew's and site of the Little Chapel. The name means literally the valleys of the Belics (or Blicqs) family. Some mention is made of this family in records from the fifteenth century. Rue des Naftiaux is again in St Andrew's and is an example of a family name (Naftel) still common in Guernsey.

DID YOU KNOW THAT...?

There is a long list of Guernsey surnames, such as Gaignepain and Hopin, which no longer exist except in old records and in some place names. Names usually die out over several generations through natural causes. However, there was a notorious family in St Pierre du Bois by the name of Becquet, several members of which family were tried for witchcraft in the early seventeenth century, and were either burned at the stake or banished. The family name died out very rapidly after this; some members died, but others disappeared from records. Did they change their names? The last known Becquet was Daniel who died childless in 1696.

Trouteaud Opticians – a name from late nineteenth-century France.

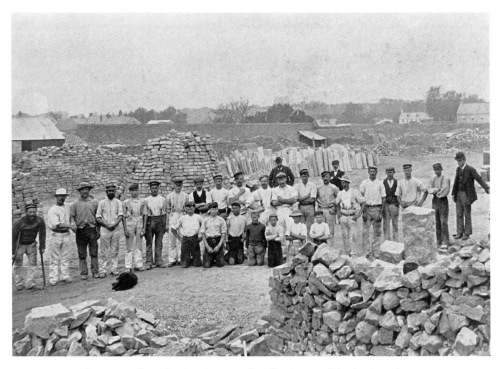

Many stoneworkers came from the South West of England to work in the Quarries.

Les Vauxbelets – valley of the Belics (Blicqs) family.

Place Names

Places names can also reflect geographical features. Given the island nature of Guernsey, it is not surprising that some words crop up again and again. There are at least thirty road names containing variations of 'Marais' or 'Mare', meaning a marsh or bog – from Rue de la Mare (Marsh Road) to Marette de Haut (The upper puddle) to La Petite Mare de Lis (Little marsh of the lily).

Other common words are *Banques*, meaning shoreline and *Fontaine* referring to a spring or well. Other geographic names are very specific and indicate subtle variations in how land was used. La Saline in Rocquaine Bay was, as the name suggests, a large salt

DID YOU KNOW THAT...?

The longest road name in Guernsey is Rue des Reines à la Grande Route aux Fosses – usually shortened to Rue des Reines. It is little more than a one-track lane which crosses the border of the parishes of St Pierre du Bois and Forest. Before the twentieth century, it was uncommon for roads of this size to have official names, and they were often simply designated by their starting point and ending point. Thus, the name means 'the road from the Reines (swampy region where frogs live) to the main road at the Fosses' (place where there are many ditches).

La Grande Mare at Vazon Bay – once a large marsh it is now home to a luxury hotel.

marsh lying just inland from the coast. However, La Salerie in Belle Grève Bay in St Peter Port was not a salt marsh but a place where fish were salted – the name indicating the occupation rather than the geography. From salting dead fish to keeping live fish, there are also several roads and fields containing the word *Vivier*, which is French for a pond in which live fish are kept specifically for food.

Other examples of 'occupational' names for roads include La Rue de la Forge, better known as Smith Street, and La Forgette, evidently referring to a smaller, minor smithy. Other more modern names are just as literal, such as 'Steam Mill Lane' in St Martin's – a rather obvious description of what could once be found in the road. A rather more interesting road of this naming type is 'Rope Walk Lane' in St Peter Port. A rope walk was a long track specifically shaped in a series of curves to help rope makers dry and twist the fibres of the ship's ropes they were making. Rope Walk Lane in St Peter Port is well preserved and is well worth a visit.

Names sometimes reveal not just the geography but humans relating to the environment and how they used it to their own advantage. Thus, in the north of the island on the coast of La Clos du Valle you have Les Amarreurs – the moorings, which is a beautiful little sandy bay with a stone pier, ideal for small fishing boats. Les Amarreurs is part of the larger sweep of Le Grand Havre (the large harbour). Both are on the other side of the Chouet headland from L'Ancresse (the anchorage). It does not take a genius to realise that the bays have been used for generations for fishing and angling.

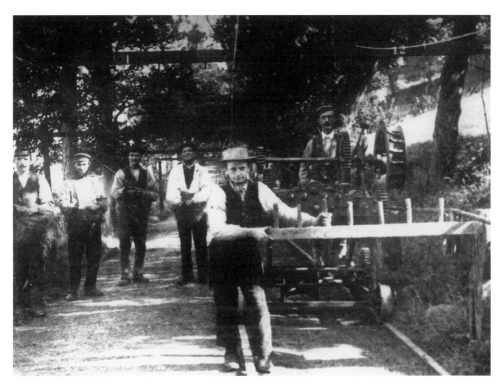

Rope Walk Lane, St Peter Port.

Pretty Les Amarreurs Harbour – an ideal mooring, as the name suggests.

Names can also reveal the secrets of Guernsey's social and political past. The island governance was feudal in nature for many centuries and some of the feudal trappings, such as the seigneurs of the many fiefs and feudal courts, still survive to some degree today. *Les Eperons*, which means 'the spurs', in the parish of St Andrew's is the name of an area, an estate and a fief. It was included in land records as far back as 1331. For many centuries until 1760, it belonged to the de Garis family. The name of the fief supposedly refers to the requirement of the seigneur of the fief to pay his feudal dues to the Crown in the form of spurs, although there is very little evidence that this actually occurred. However, one of the last de Garis seigneurs acquired some golden spurs in 1675, which can be found today in Guernsey's Royal Court. The family story tells that the spurs were a gift from King Charles II and that the seigneurs of Les Eperons were charged to give them back to the reigning monarch as a gift whenever a visit to the island was made. When Queen Elizabeth II visited Guernsey in 1978, the Dame of the Fief des Eperons duly presented the Queen with the spurs as her ancestors had allegedly promised to do.

Oddities

So far in this story, the naming of roads and places has at least been logical. However, it will come as no surprise that Guernsey has its share of the unusual, fanciful and plain odd when it comes to naming things. Take Rue de L'Angle for example, which is near Le Friquet in Castel parish. The name means exactly what it looks like – 'on an angle'. However, the road is actually fairly straight. Does it simply mean that it starts at an angle from Le Rue du Friquet, or is this a joke? Odder still is the charmingly named La Rue du Dos d'Ane, also in the parish of Castel. This literally translates as 'the donkey's back'. The most common explanation for this is that the road is very rough and bumpy with dips and climbs and odd corners. However, an alternative theory requires that the road, which runs along a high ridge, is viewed from the Vazon coast road. From there, it might appear to some as though the shape of the ridge resembles the characteristic shape of a donkey's back.

DID YOU KNOW THAT...?

At the curiously named Bailiff's Cross in St Andrew's can be found an old pre-Reformation stone at the crossroads, which has been inscribed with a cross. Its original purpose and meaning are unclear. A popular theory ties it to a legend of an early Guernsey Bailiff called Gaulthier de la Salle. The legend tells of how Gaulthier tried to frame a local landowner for theft so that he could steal his land. The plot was uncovered and Gaulthier was sentenced to death by hanging. On his way to the Gibbet he stopped at the stone to receive the final sacrament. Whatever the truth, the stone is now a scheduled ancient monument.

Les Eperons – the golden spurs presented to Elizabeth II in 1978.

La Rue du Dos d'Ane viewed from Vazon Bay. Can you see the donkey's back?

Also of uncertain meaning, but almost certainly intended as a joke, is Rosemary Lane in St Peter Port. The lane, too narrow and steep to take traffic, winds up the hill above Fountain Street and around a place now known as Mignot Plateau before it ends midway up Cornet Street. In the Middle Ages, the area was a defensive fort called Le Tour Beauregard and later, when the houses in Cornet Street were built, the area became notorious as a narrow and unpleasant slum. In other words, there is nothing here that would justify such a pretty and verdant name for the little lane. It seems likelier that it was dubbed 'Rosemary Lane' as an ironic commentary on what must have been a very smelly place indeed.

To finish this little tour of Guernsey names, old houses and a working water wheel can be found in a beautiful valley in the parish of St Pierre du Bois old houses. This is Rue de Quantereine (sometimes spelt as 'Cantereine'). The name derives from the old French '*Chant*' to sing and '*Reine*' frog – the road of the singing frog.

Left: The steep and narrow Rosemary Lane. There are no herb gardens in evidence!

Right: The inscribed stone at Bailiff's Cross.

9
CANDIE GARDENS

Guernsey is justly proud of its pedigree for growing and cultivating beautiful plants. Writing in 1862, the geologist and Fellow of the Royal Society, David Ansted, commented in his book, *The Channel Islands*,

> It is not possible to exaggerate the rich luxuriance of vegetation in carefully-cultivated gardens to be seen in sheltered localities in Guernsey. This is recognised not only in the great variety of foreign, and often tropical trees, that grow in the open air, but in their magnitude and the freedom of their growth.

With its temperate climate and fertile soil, Guernsey has a rich agricultural history, but private and public gardens and flowers in abundance have also featured highly. From the grand fields, meadows and trees of Saumarez Park to the formal elegance of Cambridge Park, and the little patches of formal garden scattered around the island, the Guernsey people have always appreciated an attractive patch of green in which to stroll. A favourite spot are the gardens at Candie, perched high on the hill above the St Peter Port seafront. The climb is worth the view and, combined with a long and fascinating history, the gardens make for a memorable visit.

Mr Mourant's Garden

In the 1780s, merchant Peter Mourant purchased the Candie estate from Mr John Cornelius where he built himself an elegant Georgian home and established his gardens. The estate was extensive and covered a much larger area than it does today. It included L'Hyvreuse Mill, now the site of Victoria Tower, a large field on the south of Candie

DID YOU KNOW THAT...?

The history and origin of the name 'Candie' has been a matter of dispute and discussion for many years. There is also a Candie Road in the parish of Castel, which was first mentioned in 1686. The likeliest explanation is that it comes from the Celtic word 'Condate', which means a confluence of waters. The name of the French town of Candé in the Loire region is also believed to come from this root. Old maps of Candie in both St Peter Port and Castel show a large number of streams, and there are several wells in the Candie garden area lending credence to this theory.

Road, which he later sold to William Bell and which later became Candie Cemetery, and land at the foot of Vauxlaurens Lane, which was sold to Joseph Gullick and became the site of a successful brewery.

Peter himself was the son of Jerseyman Stephen Mourant and had made his home in Guernsey running a successful wine and spirit importation business. In common with many merchants of the time, he purchased his estate, built his house and developed his land away from the hustle and bustle of central St Peter Port. W. T. Money, visiting Guernsey in 1798, commented that Candie was 'the sweetest place in Guernsey, about a quarter of a mile from the Town, yet so far above us ... to command the most picturesque scenery of the other islands'.

Mourant, despite being a 'martyr to the gout', was also very fond of gardening and, as the painting by Cecilia Montgomery shows, planted many varied and exotic plants in his gardens. It is thought that he designed the garden in two halves – the 'upper' was a plantation of exotic and native species, the 'lower' was a fruit and vegetable garden as it was in a more sheltered position. In 1792, he built a greenhouse in the lower gardens, which is still standing today and is thought to be one of the oldest domestic greenhouses in the British Isles. He is known to have been the first Guernsey resident to grow grapes and pineapples. The pineapples did not catch on, but grape vines became a very important and lucrative export in the nineteenth century, with many Guernsey growers exporting them to Covent Garden market on a daily basis.

Peter Mourant's son, also called Peter, was born in 1770 and in due course inherited Candie when his father died in 1807. Peter Jnr married Sophie Carey and the couple lived at Candie until Peter's early death in 1827. It is highly likely that both Peters were responsible for planting some of the older trees to be found in the present gardens. One of the oldest, a massive Turkey Oak that was at least 200 years old, had to be felled in 2007 due to a fungal infection. However, some old specimens remain, including a large and beloved Gingko (Maidenhair) tree in the lower gardens.

From Private to Public Gardens

Sophie outlived her husband by more than thirty years, but Candie was too large an estate for her, especially as the couple had no children, so it was sold in its entirety to Joshua Priaulx in 1836. It is unlikely that Joshua Priaulx, also one of the breed of wealthy Guernsey Merchants, saw the Candie estate as anything more than an investment. He was only thirty-three years of age when he bought it and had his sights set on better surroundings yet. In 1859, having made his fortune, he purchased the larger and by far grander estate of Mount Durand – known popularly as 'The Mount'. This estate is known today as Government House – the home of the lieutenant-governor, the Queen's representative in Guernsey. The extent of the Candie estate can be seen in the 1843 map of St Peter Port at a time when Joshua Priaulx was in residence.

In 1859, Joshua sold the estate to his younger brother Osmond de Beauvoir Priaulx, who may also have considered the purchase an investment as he never lived in the house. He did, however, rent the house to Guernsey's Bailiff, Sir Peter Stafford Carey, until Sir Peter died in 1886. Osmond de Beauvoir Priaulx, in the meantime, lived happily and grandly at No. 8 Cavendish Square, London, where he entertained many literary friends including

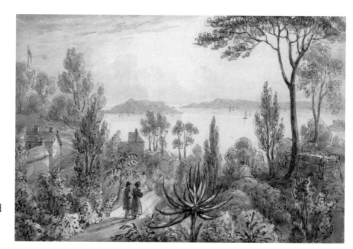

Mr Mourant's Garden, painted by Cecilia Montgomery in September 1831.

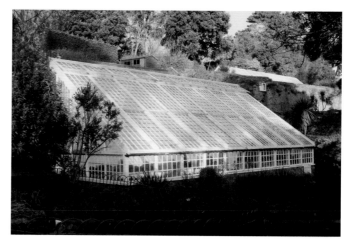

Peter Mourant's 1792 vinehouse.

The old Candie Gingko tree in its bright autumnal colours.

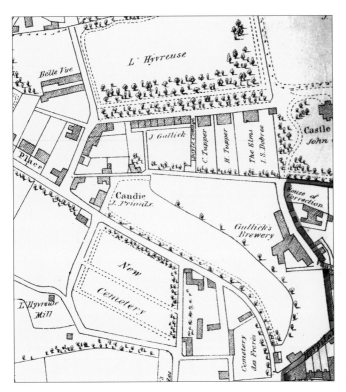

Candie estate on the 1843 map of St Peter Port.

Erasmus Darwin, Capt. Marryat and William Makepeace Thackaray. As the literary circles he frequented imply, he was an avid book collector. However, being wealthy, having no children of his own and being of a philanthropic disposition, thanks to the influence of his father Anthony Priaulx (*see chapter 4*) he was determined to make a gift of the Candie estate and his books to the people of Guernsey.

Priaulx's intentions quite naturally developed over time and he eventually agreed that a free library should be founded with his books as the core of the collection. The initial agreement with the States of Guernsey was drawn up in 1869, and the contract stated that the gardens of Candie House, also part of the gift, could, if the states wished, be sold as building land so that the library could have a large endowment for its future development. There is no doubt that had the land been sold and developed the Priaulx Library could have become much larger and better staffed. However, what was of detriment to the library was of enormous benefit to the public who can enjoy the lovely gardens to this day. A. C. Andros, and journalist and friend of Priaulx wrote,

> There is literally no public place in Guernsey where there is such a view obtainable as at Candie, and now that it has become the property of the States ... we confidently rely on its becoming in the immediate future a resort of unqualified enjoyment to the Guernsey Public as well as to the countless visitors who throng to our shores.

DID YOU KNOW THAT...?

There is a message from Osmond de Beauvoir Priaulx to the people of Guernsey inscribed in brass above the north fireplace on the ground floor of the Priaulx Library. It is in Latin and reads, 'I, a Sarnian, Osmond de Beauvoir Priaulx, have placed my books, the solace of my life, in this library, and given them forever to the people of Guernsey, in the 82nd year of my life. As they have profited me, so may they profit you.'

A Place of Entertainment

The gardens of Candie House did indeed become a popular spot with locals. A 'Grand Fête' was held in August 1890, which apparently attracted thousands of locals, including those from the outlying parishes. Such was the demand for music and entertainment that a bandstand was commissioned, completed in 1893 and opened in May of that year, partly funded by money from the Royal Court. *The Star* newspaper reports that during the opening ceremony, the paths in the gardens were lit with Chinese lanterns and fairy lamps hung from the shrubs and trees.

Entertainment was to provide the theme for the next several decades in the life of Candie. The bandstand was put to very frequent use and, although it was originally intended primarily to showcase military music, it quickly became a popular venue for local orchestras, musical soirées and even vaudeville. The gardens played host to a series of touring Edwardian entertainers, popular in England, including such acts as The Gaieties, the Stingarees and the Jovial Cards. Ruby Wilson, a comic actress with concert party act The Gaieties, was particularly popular and appeared at Candie in 1906.

In the 1930s, a glass auditorium was built onto the bandstand. The entertainments grew in size and it continued to be a popular venue right through to the 1960s. The glass and block auditorium was not the most attractive of buildings. The historian C. P. Le Huray described it as 'monstrous' and 'unsightly', but there is no doubt that it served its purpose as a large entertainment venue and had the added attraction of being set in attractive gardens. The odd structure was dismantled in 1976 and the award-winning Guernsey Museum built in its place. The bandstand was restored to its former glory and now houses a popular café.

The Gardens Today

With the upper gardens today being a Mecca for history and culture, containing as they do both the Priaulx Library and the museum plus statues of both Queen Victoria and Victor Hugo, the lower gardens have somewhat retained their original purpose. The formal flower beds and interesting planting of the lower gardens makes it a popular spot for town workers on a lunch- break, or families with young children. Along the north boundary is a 400-foot wall that separates the garden from Vauxlaurens Lane. This was restored in 1997 under the auspices of Vivyan Hewlett. A number of specimen plants are now positioned against the shelter of the wall, including a collection of Victorian Clematis varieties and other tender plants.

DID YOU KNOW THAT...?

The most famous act to play at the Candie Pavillion was The Beatles in August 1963. The sell-out show was supported by local band The Roberts Brothers, who apparently kept the eager audience well entertained with a performance of 'Old Macdonald's Farm'. When The Beatles appeared, they opened with 'Do You Want to Know a Secret?' before launching into some of the recent hits and finishing with John Lennon singing 'Twist and Shout'. It was their first and last visit to Guernsey.

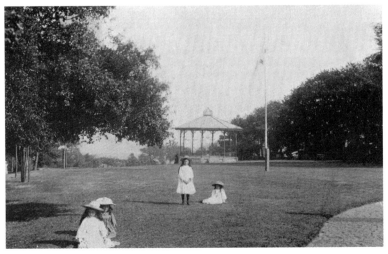

Candie Gardens upper lawn and bandstand from a late-Victorian postcard.

The Gaieties, who appeared at Candie in 1906.

The restoration of the lower gardens in 1997 involved a strong eye for detail and the careful symmetry of the beds and paths has all the formality one would expect of a large country house. There are even Victorian fish ponds to enjoy. Peter Mourant's glasshouse was designated a bulb house, and the Guernsey Branch of the National Council for the Conservation of Plants and Gardens undertook the planting of the South African bulb collection.

Candie Gardens Pavilion in the snow, Christmas 1962.

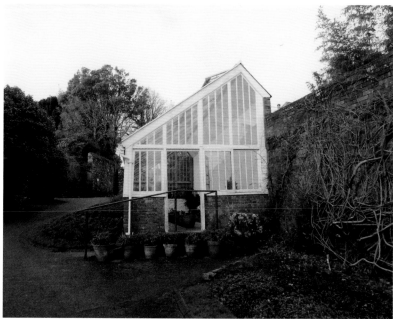

The 'upper' greenhouse in Lower Candie Gardens.

10

THE GUARDIANS OF STONE

The Channel Islands are rich in prehistoric remains and important megalithic monuments representing almost 250,000 years of human habitation. In Guernsey, some of the passage graves – particularly Déhus and La Varde – rival some of the most impressive graves of Southern Brittany. The full and fascinating history of the archaeology of the archipelago can be found in a number of authoritative books (*see bibliography*), but this chapter will examine an altogether rarer phenomenon – carved stones.

Sculpted and carved Neolithic stones are found throughout Europe, yet in Guernsey the examples are truly exceptional. Two statue menhirs survive, unique to the Channel Islands, and rare even in the Neolithic-rich landscape of Brittany. Both are around 4,000 years old. Older still (around 6,000 years) is a carved figure on a capstone at Le Déhus passage grave, a mysterious presence who stayed hidden for many centuries. These carvings are all worth visiting – not only are they impressive, but they show early man interacting with the environment in an intimate and recognisable way. Millennia later, they still have power and play a part in the rich cultural traditions of the island.

A Trick of the Light – the Guardian of Le Déhus

The large, chambered passage grave at Le Déhus in Guernsey's northernmost parish was well known as an antiquarian curiosity. In the early nineteenth century, it was usually referred to in the manner of the time as a 'Druidical temple'.

It was Guernsey's pioneering archaeologist, Frederick Corbin Lukis, who first officially excavated Le Déhus in 1837 and spent nearly ten years painstakingly recording it. When he first encountered the grave, it was partially open to the elements – the second giant capstone (nearly 4.5 metres long) was broken off at one end, and the broken part lay on the floor of the 5.5-metre central chamber. He also found four smaller ante-chambers,

DID YOU KNOW THAT...?

9,000 years ago, Guernsey and the rest of the Channel Islands were part of the French mainland. At the very beginning of the Stone Age, between 8,000 and 6,500 BC, rising tides cut the islands off from the continent, and Guernsey, being further west, was very likely to have been an island a long time before Jersey was finally isolated. One of the oldest prehistoric monuments in Europe is Les Fouillages on L'Ancresse Common in Guernsey, parts of which date from around 6,500 BC.

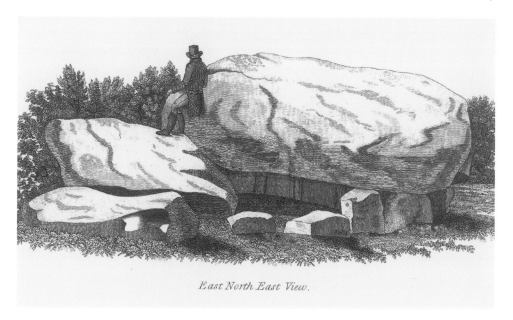

East North East View.

'View of the Temple called *La Pierre du Déhus*', Royal Society of Antiquaries, 1815.

which showed evidence of burials from the late-Neolithic through to the Bronze Age – all remarkable discoveries. Despite his ten years of work, he never discovered the figure of a man carved on the underside of the broken capstone.

Nearly sixty years later, Revd G. E. Lee, a local historian and antiquarian, also excavated the tomb. Although many of the large stones were still in situ, some had fallen, such as the carved capstone, and some had been moved. He returned them to what he believed to be their original positions and he also repaired the broken second capstone, binding the detached part with metal rope and securing it in place with oak posts. The face and part of a hand are carved on the detached part of the capstone, and it seems scarcely likely that Lee could have failed to spot it. However, such was the case! It was not until 1917 that T. W. G. de Guérin found carved lines on the stone, but even then did not identify the carving fully until 1918.

How could the petroglyphic figure have remained hidden for so long? The answer lies in a trick of the light. Much like the writing on a weathered tombstone, the carving cannot be seen in bright dispersed light. Only a strong light from one direction casts shadows on the rocks and allows the figure to emerge. *Le Gardien du Tombeau*, as the figure came to be known, was fully described by de Guérin who interpreted it as the face of man, with eyes, mouth, strong eyebrow ridges and a beard. There are vertical lines that appear to be the figures of a hand and a suggestion of a bow and arrow and a belt or girdle. The Guardian is a dramatic sight and a rare example of Neolithic art – the vast majority of which is abstract. De Guérin noticed that the inner line of the Guardian's right arm continues up and around the top of the capstone, indicating that the figure was carved before the tomb was built and is thus of great antiquity. It is possible that it was once a standing stone which was then reused when the passage grave was constructed between 3,500 and 2,000 BC.

Interior of Le Déhus chambered passage grave in 2014.

Why was this figure carved and what does it mean? These are questions asked for many decades of this type of art and there is no definitive answer. It is likely it was a pagan interpretation of a god or god-like figure, but the uniqueness of the bearded figure suggests it may have been a purely local god. Whatever its meaning, there is no denying its mysterious power. During excavations by Mond and Collum in 1932, the circular mound that covered the grave was reconstructed and a visit to the Le Déhus today finds it low and dark, until dramatic lighting reveals the Guardian from his hiding place.

The Two Grandmothers

In the later Neolithic period (around 3,000 to 2,000 BC), statue menhirs began to emerge in Europe – mainly in the south-west of France, Spain and Italy. They are, as the name suggests, menhirs (literally 'long rocks') that have been carved to represent human form. Highly stylised and sometimes intricate, they are fascinating pieces, probably created as representations of powerful beings, gods or people – perhaps for protection or for worship.

DID YOU KNOW THAT...?

The names *Déhus* and *Déhuset* are found in Guernsey documents as early as the fourteenth century, and are used for several standing stones and dolmens. The name is of Celtic origin and probably comes from the Old Gaulish *Dusius*, meaning 'demon'. Georges Métivier writes of a Breton legend in which the Déhuset is seen to dance around a cromlech when he is called forth.

 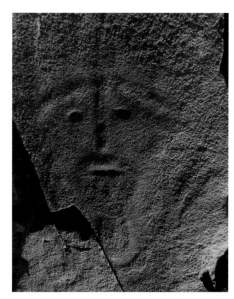

Left: Where is he? Le Gardien capstone without an angled light.

Right: There he is. Le Gardien du Tombeau is now visible.

Since it is most often female, goddess-like figures that are represented, they are sometimes called 'Grandmother Stones'.

Guernsey has not one but two 'Grandmothers' of its own. Unique in the British Isles (none are found in the United Kingdom), these statue menhirs have stood guard for many thousands of years.

'La Gran'mère', the statue-menhir that typically stands in the graveyard of Castle parish church, has had a chequered recent history. Like Le Gardien du Tombeau, she lay hidden for many centuries, forgotten by the descendants of those that created her, waiting to be rediscovered. When the church was redecorated and restored in 1878, she was found lying beneath the entrance to the chancel, her feet pointing to the east as though in a Christian burial – surely not a coincidence. Perhaps her 'burial' there was an attempt to Christianise an ancient pagan site upon which she once stood sentry when the church was first built in the sixth century?

DID YOU KNOW THAT...?

Menhir is a Breton word meaning Stone (*men*) and Long *(hir)*. These Long Stones, or *Longue Pierres* are fairly numerous in the Channel Islands, existing as a single standing stone (monolith) or as part of a larger group (megalith). The largest of all is La Longue Rocque in the western parish of St Pierre du Bois, which stands alone in a field with a view to the sea. It is more than 4 metres high and probably weighs about 5 tons.

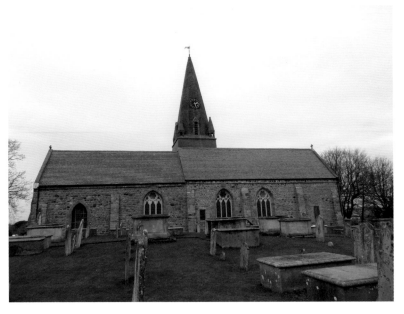

Ste Marie du
Castel parish
church.

To modern eyes, the carved menhir (6 ft 6 inches in height) looks like a crude and not very accomplished attempt to model a female form. However, of its type and age, the Castel Grandmother is remarkably sophisticated. Firstly, the ancient sculptor has made an attempt to model shoulders, and careful examination reveals a headdress of some sort – possibly a crown. Also, her 'girdle' is clearly seen running all the way around the back of her shoulders. This makes her quite unique as none of the surviving 'Grandmother Stones' in western France are carved in the round.

According to esteemed archaeologist Kendrick, the distinctive 'collar' of the statue, above the round breasts in high relief, is comparable to the carvings found in Oise and Seine, north of Paris, and could indicate that the people who carved her followed the same cult of the Mother-Goddess. She is probably early Bronze Age in date.

The garland found atop La Gran'mère's head was a happy accident on the occasion the photographs were taken – she had been decorated (in a particularly pagan manner) for Christmas 2014. At her feet can often be found little 'offerings' made by islanders in her honour.

Remarkably for such a small island, the 'Gran'mère' at Castle has a younger sister at the neighbouring parish of St Martin's. La Gran'mère du Chimquière, to give her full title, has a girdle and breasts, just like her Castel counterpart, but in contrast has a fully shaped head with human features and a headdress and collar. She is therefore something of a puzzle, for below the head she has much in common with the ancient statue-menhirs of France, but the strong carving of her shoulders and neck is similar to carvings found in Corsica and parts of the Mediterranean. It is possible that she was carved at two separate times – the head possibly created as late as the Gallo-Roman period. There is no definite consensus on the date of her creation, partly because in many ways she is unique.

Unlike the Castel statue menhir, the St Martin's figure has been a well-known and loved object of veneration and appreciation for time immemorial. She now acts, rather ignobly,

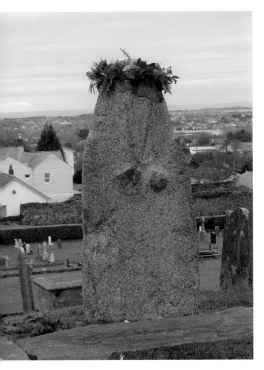 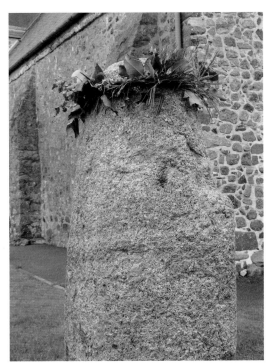

Left: The Castel statue-menhir has been repositioned to overlook the cemetery.

Right: A rear view of the statue-menhir showing the girdle carved 'in the round'.

Small 'offerings' made to the Castel statue-menhir at Christmas 2014.

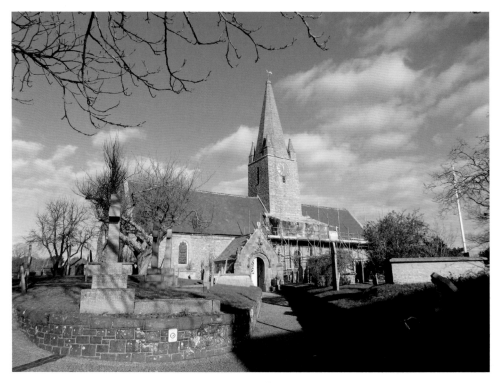

The parish church of St Martin de la Bellouse.

as a gatepost, but it is said that she once stood much closer to the church – indeed within the church grounds. Folklorist Marie de Garis relates a story (which may or may not be true) about how La Gran'mère came to be moved.

Around 1815, an over-zealous churchwarden by the name of Tourtel became increasingly angry at the way the parishioners of St Martin's venerated the idolatrous statue, leaving gifts of flowers at her feet and touching her for good luck. In the dead of night, he stole to the graveyard and threw her to the ground where the granite column she was carved from split into two parts along a natural fault line in the stone. The next morning, the angry parishioners demanded that she be repaired, so she was moved to just outside the church grounds and cemented back together again – where she has remained ever since. The story is no-doubt apocryphal, but it is highly likely that the church was built upon a prehistoric sacred site, so the statue-menhir would have certainly stood closer to the church than it does today.

The devout churchwarden's actions had little effect on the parishioners; even in the twenty-first century it is still possible to visit La Gran'mère du Chimquière on a spring morning and find a gift of flowers laid at her feet. Indeed, it is traditional for brides being married at St Martin's church to have a garland woven for La Gran'mère out of the bridal flowers, which is then placed on her head as the party leave church to invoke the Mother-Goddess' blessing upon the marriage.

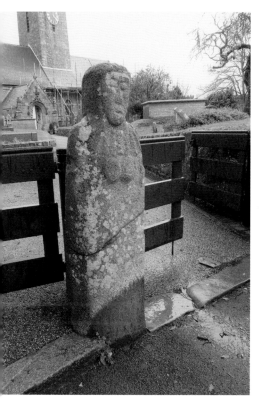

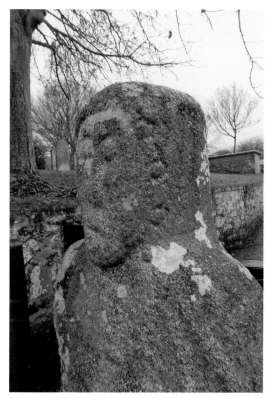

Above left: La Gran'mère du Chimquière on a winter's day. She is 2,000 years older than the church she stands before.

Above right: Carved curls can be seen around the menhir's face.

Below: La Longue Rocque, St Pierre du Bois.

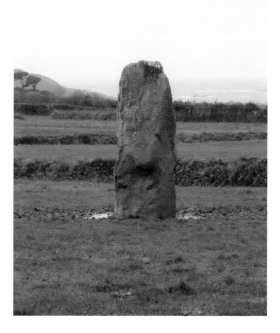

BIBLIOGRAPHY

Andros, A. C., *Reminiscences of the Late Mr A. C. Andros* (Guernsey: Guernsey Star, 1902).

Ansted, David Thomas. *The Channel Islands* (London: W. H. Allen, 1862).

Ashelford, Jane, *Royal Journeys: Victoria & Albert in the Channel Islands* (Jersey: JAB Publishing, 2004).

Bellow, Tony, *Channel Islands Witchcraft: A Critical Survey* (United States: Lulu, 2009).

Bennett, Amanda, 'Concealed Objects at the Priaulx Library, Guernsey'. (*Archaeological Leather Group Newsletter, 23*, March 2006).

Bernard, John, *Retrospections of the Stage* (London: Colburn & Bentley, 1830).

Carey, Augusta, *Diary* [MS].

Carey, Edith, *Scrapbook*, 2 vols [MS].

Carey, L. F. de Vic. 'William Gardner's map of Guernsey, 1787', *Transactions of La Société Guernesiaise*, 1958, pp. 356–57.

Coates, Richard, *The Ancient and Modern Names of the Channel Islands* (Stamford: Paul Watkins, 1991).

Cox, Gregory Stevens, *Social Life in Georgian Guernsey* (Guernsey: Toucan Press, 2014).

Coysh, Victor, 'Fort George, Past & Present', *Transactions of La Société Guernesiaise*, 21, pp. 667.

Coysh, Victor, *A Short History of the Town of St. Sampson* (Guernsey: Toucan Press, 1985).

Curtis, S. Carey, 'The Braye du Valle up to its Reclamation in 1805–1806', *Transactions of La Société Guernesiaise*, 1923, pp. 302–09.

De Garis, Marie, 'Glossary of Guernsey Place-names', *Transactions of La Société Guernesiaise* 1976, pp. 66–103.

De Guérin, T. W. M., 'Notes on the recent discovery of a human figure sculptured on a capstone of the Dolmen at Déhus, Guernsey', *Man: A Monthly Record of Anthropological Science* (September 1920).

De Guérin, T. W. M., 'List of Dolmens, Menhirs & Sacred Rocks', *Transactions of La Société Guernesiaise*, 1921.

Falla, P. J., *Some Notes on Quarrying in Guernsey*.

Fenn, R. W. D. and Yeoman, A. B., *Quarrying in Guernsey, Alderney, and Herm* (Bardon Hall: Aggregate Industries, 2008).

Fleming, William. *The Power of the Gospel: An authentic Narrative Containing Some Remarkable Passages in the Life and Character of Anthony Priaulx* (Edinburgh: Oliphant, 1823).

Greenwell, G. C., 'The Guernsey Quarries', *The Quarry*, July 1897.

Harris, Liz and Fisher, Keith, *Guernsey on the Map: How the World Discovered the Bailiwick* (Guernsey: Small Ltd, 2004).

Henry, R. A, *The History of the Braye du Valle: The Reclamation, 1806* (Guernsey: Rosemary Anne Henry, 2004).

Gosselin, Joshua, *An Account of Some Druidical Remains in the Island of Guernsey* (Read to the Royal Society of Antiquaries, 5 December 1811).

Greenslade, T. (ed.), *Biographical Sketch of the Honorable Lieutenant General Sir John Doyle* (Facsimile of the 1806 original by Toucan Press, Guernsey).

Kendrick, T. D, *The Archaeology of the Channel Islands*, (London: Methuen & Co., 1928).

Lenfestey, Hugh, *Guernsey Place Names*, (Weybridge: RoperPenberthy Publishing, 2014).

MacCulloch, Edgar, *Guernsey Folk Lore* (London: Elliot Stock, 1903).

Marr, L. James, *A History of the Bailiwick of Guernsey: The Islanders' Story* (Chichester: Phillimore, 1982).

Pitts, John Linwood, *Witchcraft and Devil Lore in the Channel Islands* (Guernsey: Guille-Allès Library, 1886).

Sebire, Heather, *The Archaeology and Early History of the Channel Islands* (Stroud: Tempus, 2005).

Smith, David, *Antique Maps of the British Isles* (London: B. T. Batsford, 1982).

Smith, David, *Maps and Plans for the Local Historian and Collector* (London: B. T. Batsford, 1988).

ACKNOWLEDGEMENTS

As always, there are a wealth of people to thank for their advice and generosity in providing ideas and anecdotes. I would like to single out the staff of the Priaulx Library for their patience, and I am also grateful to the support of the Library Council and Trustees. I would especially like to thank my family and my sister Tammy for producing the helpful map at the beginning of the book.